KU-315-670

BEOMSIK WON

BEOMSIK WON

BEOMSIK WON
Archisculpture

Edited by the ILWOO Foundation, Seoul
With a preface by Suejin SHIN and an essay
by Marc Prüst

HATJE
CANTZ

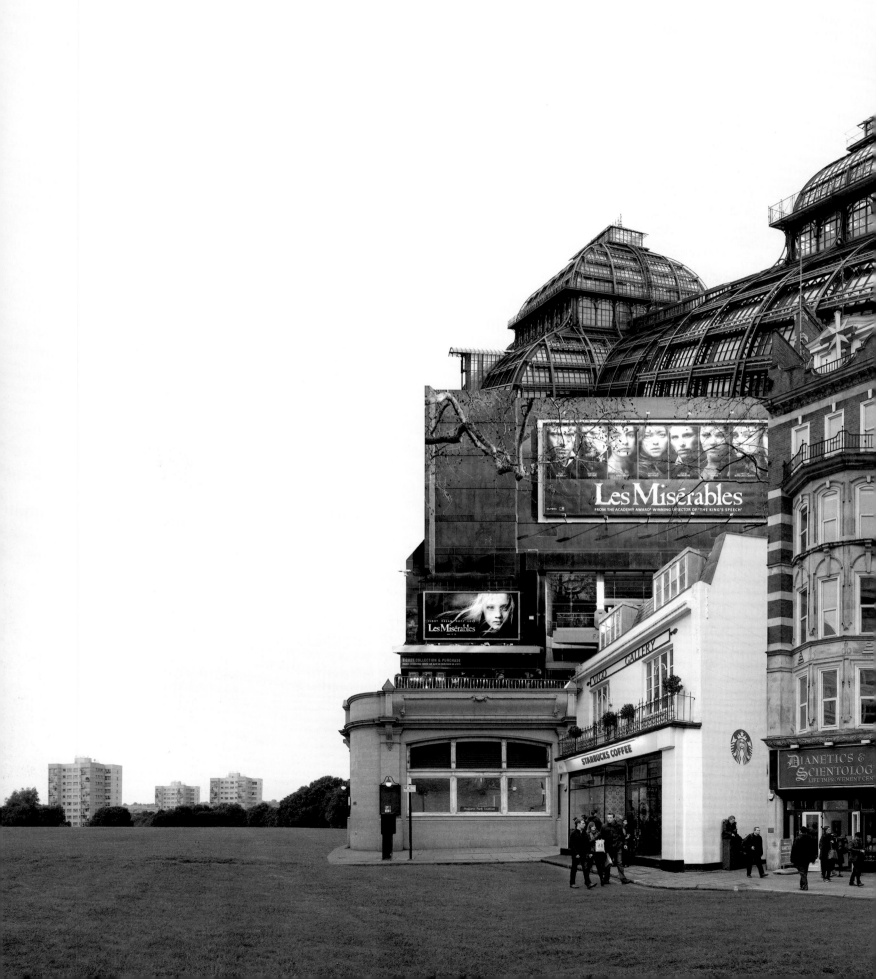

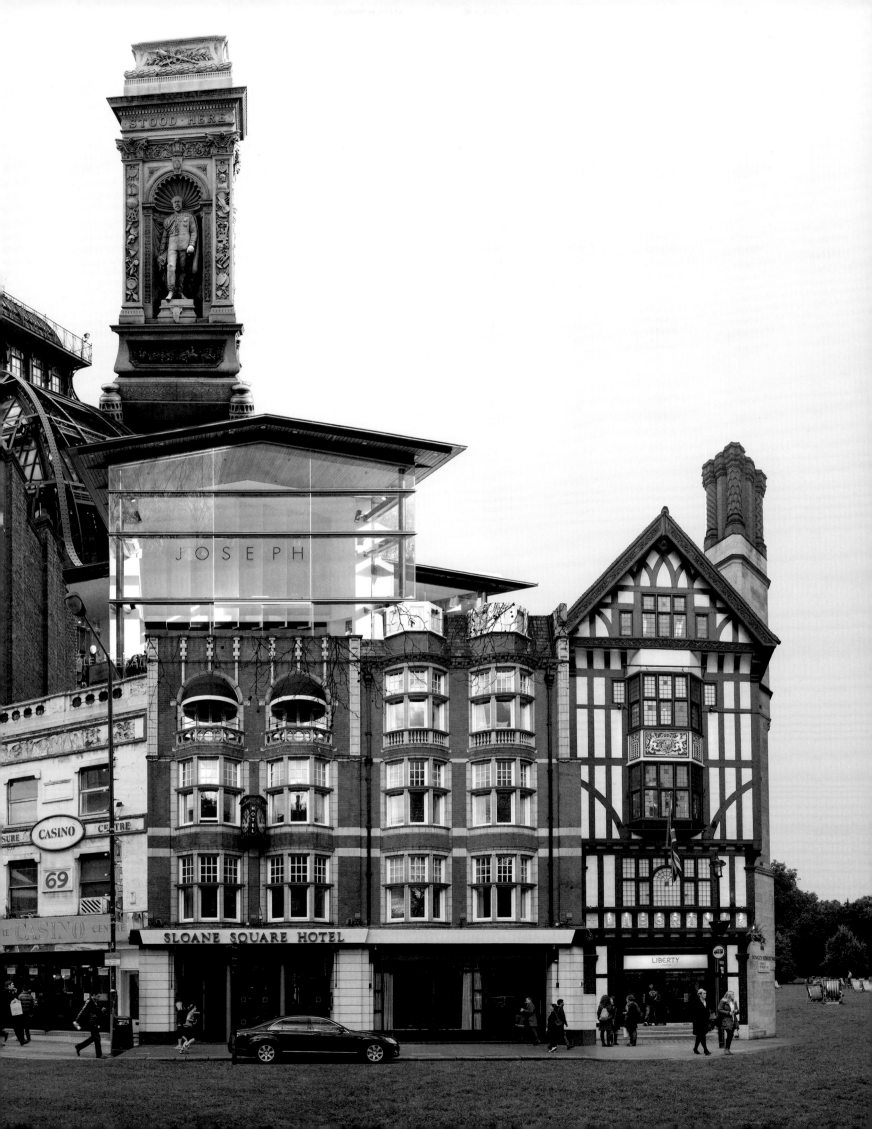

PREFACE

Suejin SHIN
Photography psychologist
Creative director, ILWOO Foundation

This book is published as part of support for the winner of the 2013 ILWOO Photography Prize. Among the many ways to present one's work, a monograph is perhaps the most conventional and effective method of discussing a body of work in depth. The medium of photography, above all others, has the ability to retain its original quality in a book format. Mass-printed photographs are inevitably different in their sizes and textures when compared to the framed images, but they sufficiently provide the intended visual experiences. In a way, books transcend a mere way of showing works by allowing readers to enjoy and imagine at their own pace. It is another experience that gives new life to artworks unlike looking at large, framed prints hung beneath a high ceiling.

The photographs of Beomsik WON allow us to dream. He locks up big spaces in small frames and delivers them into your hands. In his works, things that cannot physically be in the same space coexist, things that cannot rely on each other support each other, while sequentially captured times are compressed in one frame. If conventional photography teaches us ways of seeing, WON's works teach us ways of imagining enabled by digital processing. He nonchalantly makes up buildings that cannot exist in real life. When you look at the buildings made by patching up collected materials instead of stacking up bricks, ordinary rules lose their meaning. The happy world of imagination realized by persistent working conveys a delicate tension between boring endurance and a feeling of freedom.

The artworks of WON are playful. If we can find good effects of art in open-ended questions, the biggest virtue of his works can be found by asking, "Why not?" WON builds his own world based on his own rules. From an early stage in his career, he has experimented with a "visual playing" between the flat surface and three-dimensional space. For example, his early work *Crumpling*

Project focused on the process where a piece of paper was crumpled and thrown to become a three-dimensional structure. This illustrates that he is interested in a revolutionary conversion that he can imagine from daily scenes. WON has developed his own method whereby he arbitrarily chooses formulas and principles of composition and rearranges daily scenes accordingly. As a result, his photographs disturb the order and follow the order at the same time.

WON tries to actively deconstruct established orders such as gravity and perspective. The scenes chosen from different times and spaces are removed from their original contexts and become independent materials. However, when he patches up the materials, he pursues balance and harmony to make the result look as if it were originally one building. The countless times and spaces collaged in his photographs are puzzles of history made with fragments of time.

The photography of Beomsik WON is situated between established conventions and new perspectives. In fact, the techniques he uses are not extremely complicated or sophisticated. Digital processing techniques provide nothing more than a relatively convenient means to realize his imagination. The process of collecting images is very similar to conventional street photography and digital compositing is not that different from early twentieth-century photomontage. He travels around the world and takes pictures of the interiors and exteriors of many buildings with his camera. It doesn't matter what buildings attract his attention. Just by immersing himself in efforts to create more elaborate and natural structures, WON shows new perspectives representing the present day without any grand narratives. Considering that it is the "liquidity," the quality of floating lightly, that makes the most powerful innovation in these days, Beomsik WON's photographs are indeed contemporary.

The publication of this catalogue required a long period of preparation. I'd like to thank Chang W. LEE, staff photographer at *The New York Times*, Markus Hartmann, the former international program director at Hatje Cantz, Juha CHUNG, a professor and artist, and Sunhee KIM, the director of the Daegu Art Museum, who have spared their valuable time to communicate with artists and to evaluate portfolios for the 2013 ILWOO Photography Prize. I would also like to show my appreciation for the sponsorship from Hanjin Group, which made everything possible. I sincerely hope this project will expose Korean talents to enthusiasts around the world, and encourage WON and many other devoted artists who even at this moment strive to realize their creative visions against all odds.

WHAT IS BEOMSIK WON?

Marc Prüst

Beomsik WON is a collector. He'd been collecting buildings, photographs of buildings to be more precise, for years. Until he realized that by merely capturing what was already there, it was the architect's creativity that was apparent, and not his own. It led him to use this seemingly random collection of photographs of buildings from all over the world, including Seoul, London, New York, Cairo, Venice, Beijing, Pisa, Jerusalem, and many others, for a new project. The images thus became the starting point for the *Archisculpture* project. In this monograph we find two chapters of this continuing work: Antigravity and Collage. The principle of the images is the same: all the works are composites, collages, recreated structures from pieces found in these cities all over the world. Underlying these images is a theoretical justification that references French philosophers Jacques Derrida for the Antigravity works and Roland Barthes for Collage.

Beomsik WON is a philosopher. Deconstruction, as conceptualized by Derrida, rejects principles that underlie practical architecture, such as gravity. WON's constructions may perhaps be seen as the visual proof of this theorem, particularly those of the Antigravity chapter. The Barthesian concepts of the *punctum* and the *studium* are central to WON's philosophical construct for the collage series. *Punctum* can be described as the element in a picture that grabs and holds the attention of the viewer. *Studium* is the interpretation of the photograph, as it exists in a larger context—culturally, politically, or otherwise. Each element in these constructions can, according to WON, be seen as the artist's *punctum*. The illusion of the non-existing metropolis that we see in the images is then the *studium* of these images. With this analysis we find ourselves at the core of photographic theory, as indeed, we are speaking here of images, pictures, of photographs.

Beomsik WON is a photographer. He photographs different elements of various buildings, and reconstructs them into photographic art pieces using software. The resulting works are formal images in the typology tradition of Bernd and Hilla Becher: black-and-white images with a large tonal range of grays. These are formal structures presented from a distance, with an extensive depth of field. The light is even, with skies that render a visual without shadows. The horizons are low and unobtrusive, and the relative size of the buildings within the frames is very similar. We speak of typologies when the subject of a series of photographs is similar and the photographs are indicative of small variations that exist between the photographed objects. In the case of these *Archisculptures* this is clearly not the case: each image is unique, not only in its construction, but also because the individual constituent elements in each frame are used only once by the photographer. That makes this series of photographs more a portfolio: a series of interrelated images in which each image represents one particular element of the overriding issue. Indeed, each image has a particular focus on combining elements of a particular city or area, to thematic structures pieced together from elements of existing theaters. That begs the question though what the overall issue is in this work: What is WON addressing with his *Archisculptures*? In order to find an answer to that question, we should perhaps analyze the word he gave to his project *Archisculptures*. Let us begin with the first part of this term, "archi."

Beomsik WON is an architect. Using the constituent elements in his photographs he creates new buildings and structures that are

proof of his creativity and open mind. The buildings he creates are a reality in a photographic sense: we see them, therefore they are, but indeed we cannot live in them. It is possible however to imagine what it would be like to actually walk up to these impressive buildings, to enter them, and to then be swallowed up by the escalators, that stretch out of some buildings like tongues from gigantic mouths. Unlike other architects, WON can work unhindered by practical considerations, as there is no gravity, lack of materials, or health and safety codes that apply to his creations. The philosopher, with his reference to Derrida is apparent here. In addition to the "archi," we have to consider the "sculptures."

Beomsik WON is a sculptor. His inspiration comes from architecture, but his creations are unique conglomerates of various pieces. We only see a photograph, a representation, but its rendition is so clear, sharp, and recognizable that we have no trouble imagining it as a physical presence. Instead of photographs of actual buildings, WON's interpretations are better versions of the familiar, well-known artist renderings and scale model versions of large architectural plans and ideas. It is a small step to imagine these sculptures as actual scaled constructions, picturing them in museum parks or public spaces where they would allow the audience to stroll in a new kind of futuristic city.

Beomsik WON is a futurist. Regardless of the number of photographs that are taken each day, and there must be billions, they all have one thing in common: they were taken in the past. The instance the shutter is released the moment is captured, and is behind us. But these images do not reflect the past instead they seem to predict a future. Whether that future is utopian, or dystopian is a matter of taste and opinion. In some images the skies are so dark, the buildings so overwhelming, the people so small that if this were a view into the city or the building of years to come, most of us would feel uncomfortable with the prospect of living in them. Others however have a lightness that breathes accessibility—welcoming people from all ages.

Beomsik WON is in fact all of the above, and none of them at the same time. Whether you want to play a mind game and test your knowledge of architecture by searching for elements from famous or not so famous buildings (That's Freddie Mercury! There's Big Ben! The Colosseum! Times Square! No, Piccadilly Circus!), to search for elements you might recognize from your own trips, the pictures you've taken yourself, the books on architecture you might have seen, or travel guides that show images from cities from all over the world, you will find it in this book. These images then become a memory game: a play between recognition and memory.

They pull you in and make you stop in your visual tracks. They allow you to explore and look into each tiny detail of the image. But as a whole they are no less rewarding. Take a step back and regard them from a respectable distance. The plates will reveal something more: look at how the structures dominate the area in which WON has placed them. The low horizon, the vast amount of space they occupy. This is where I think the collector, philosopher, photographer, architect, sculptor, and futurist actually come together: blocks placed as if they were a dollhouse, onto a field, including pavements, pedestrians, the odd car, tree, or statue. Sometimes there is a river, or a landscape covered in snow, or we can see parts of a city in the background. Instead of looking at what is, in the constituent parts of the structures, WON looks at what can be. This is the kind of photography that allows one to look into a possibility, instead of what existed in the past. We are not presented by a choice between a bright or a dim future: this work is an exploration into what may never be, and thus it gives us the opportunity to dream.

Beomsik WON is an artist.

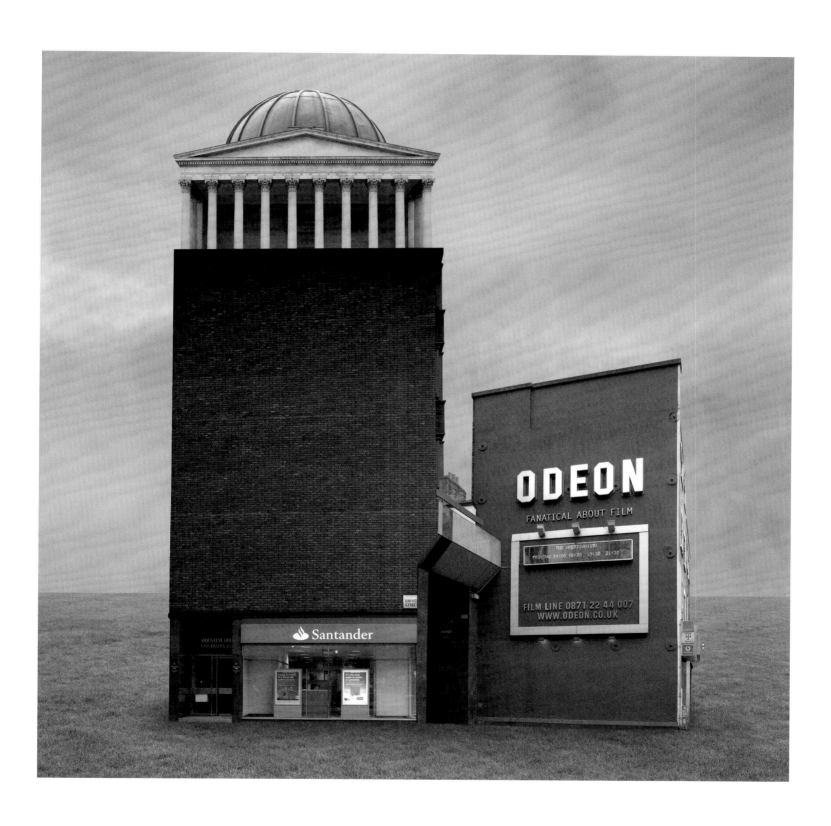

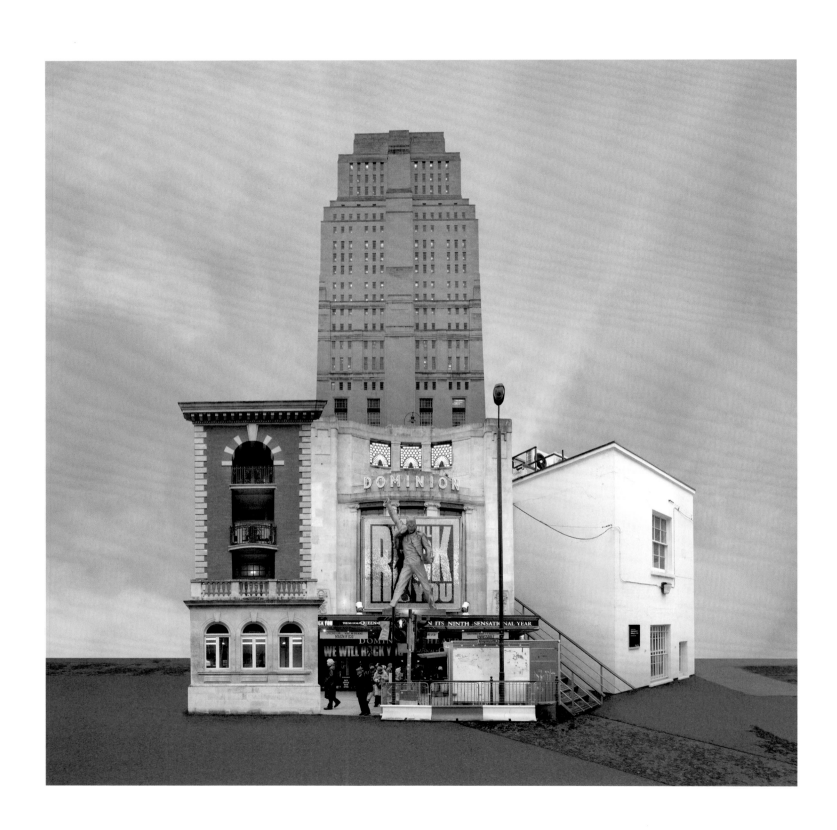

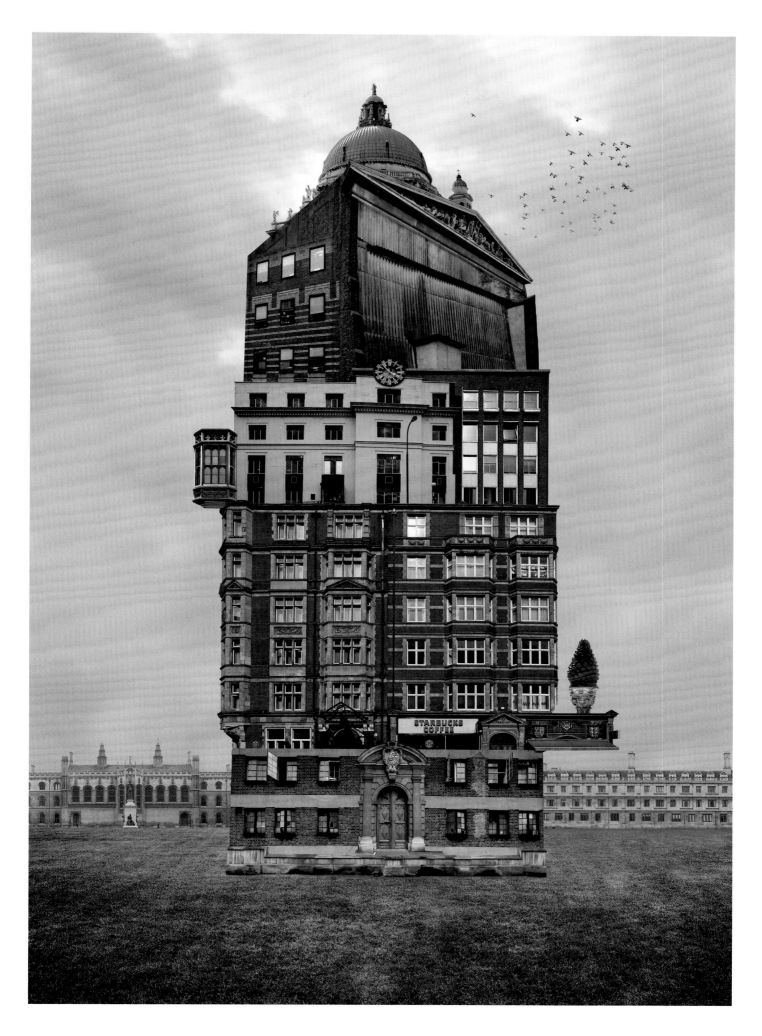

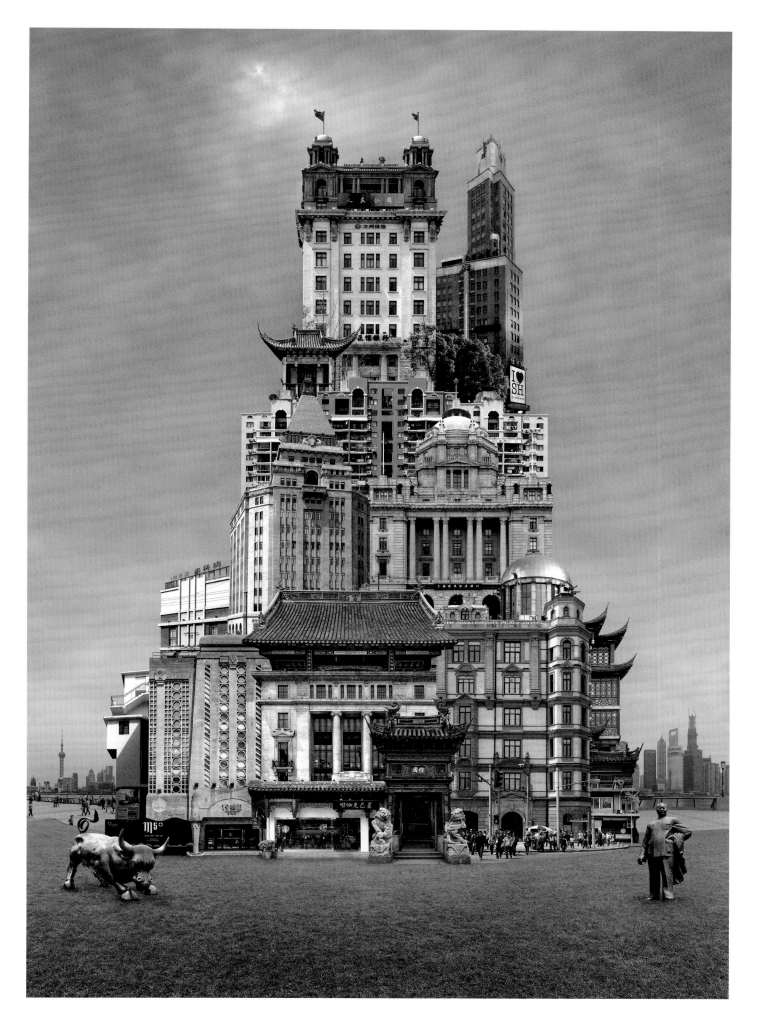

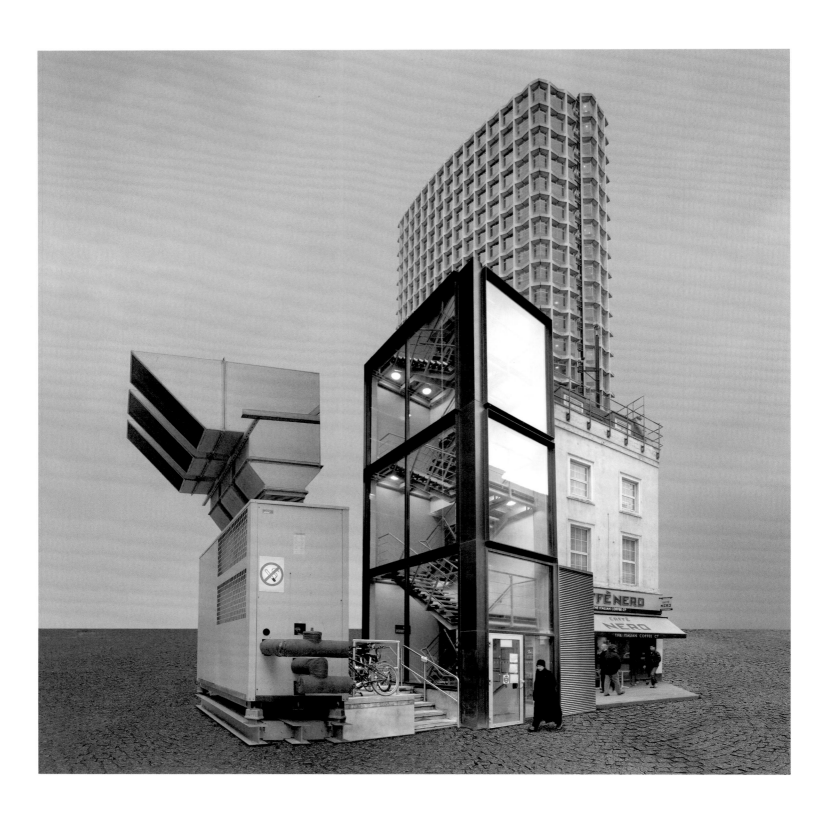

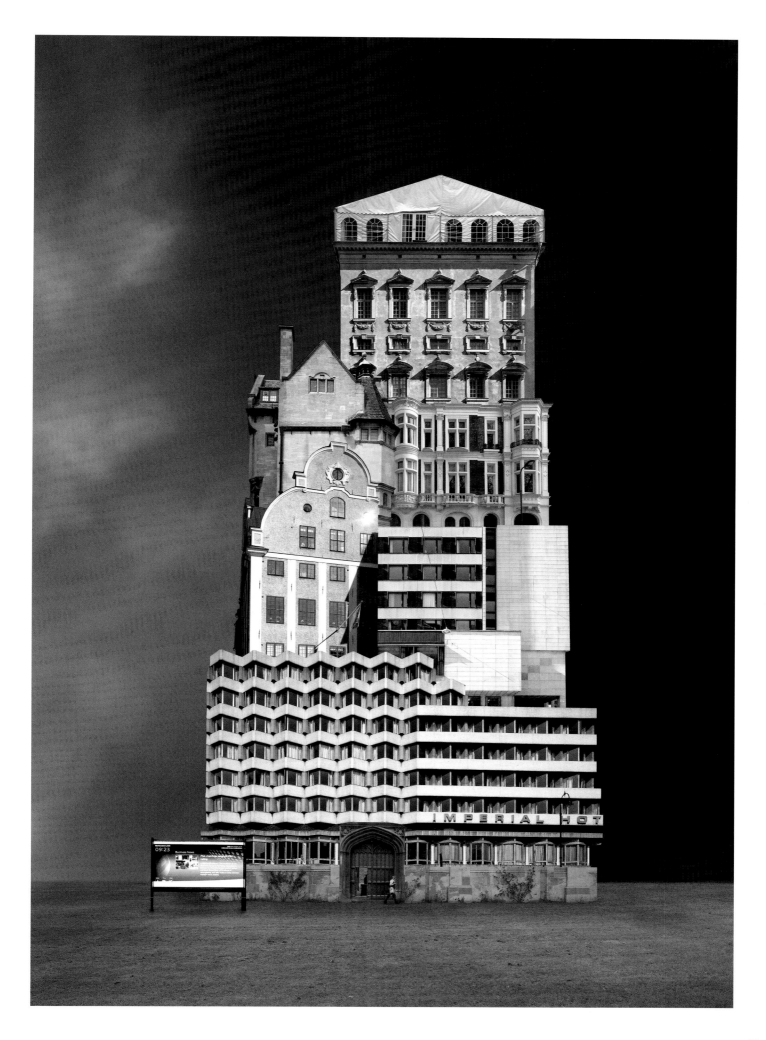

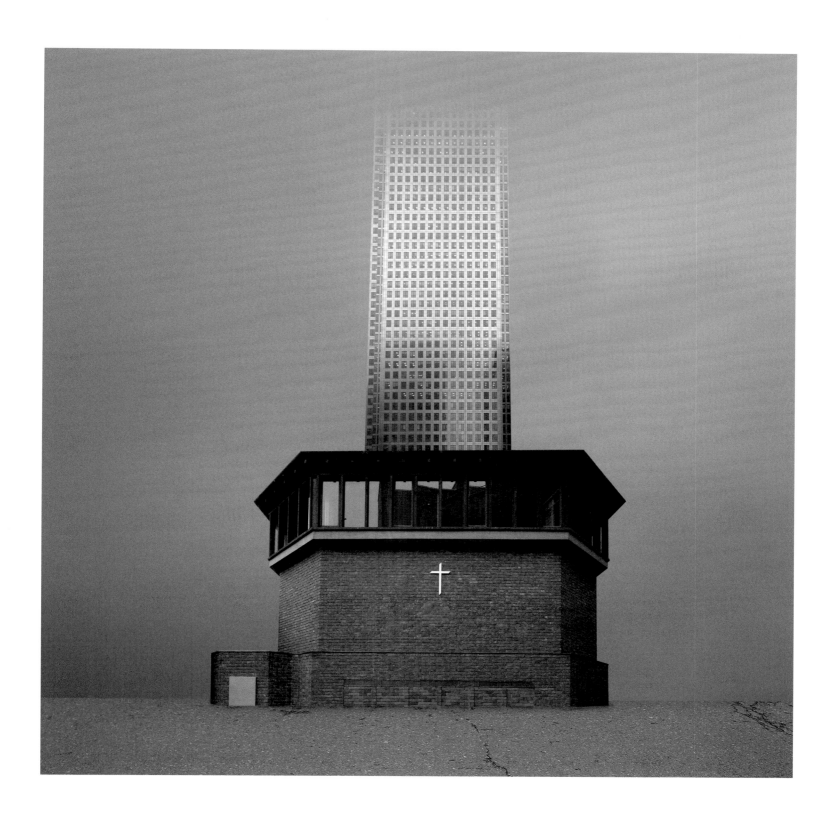

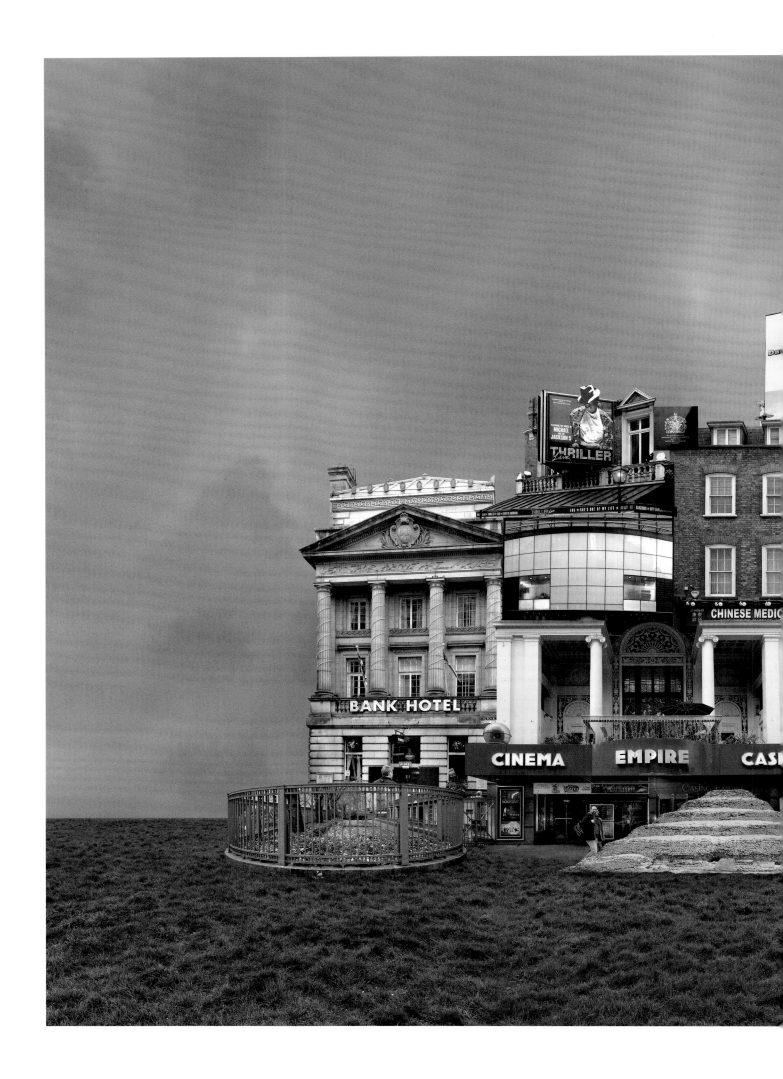

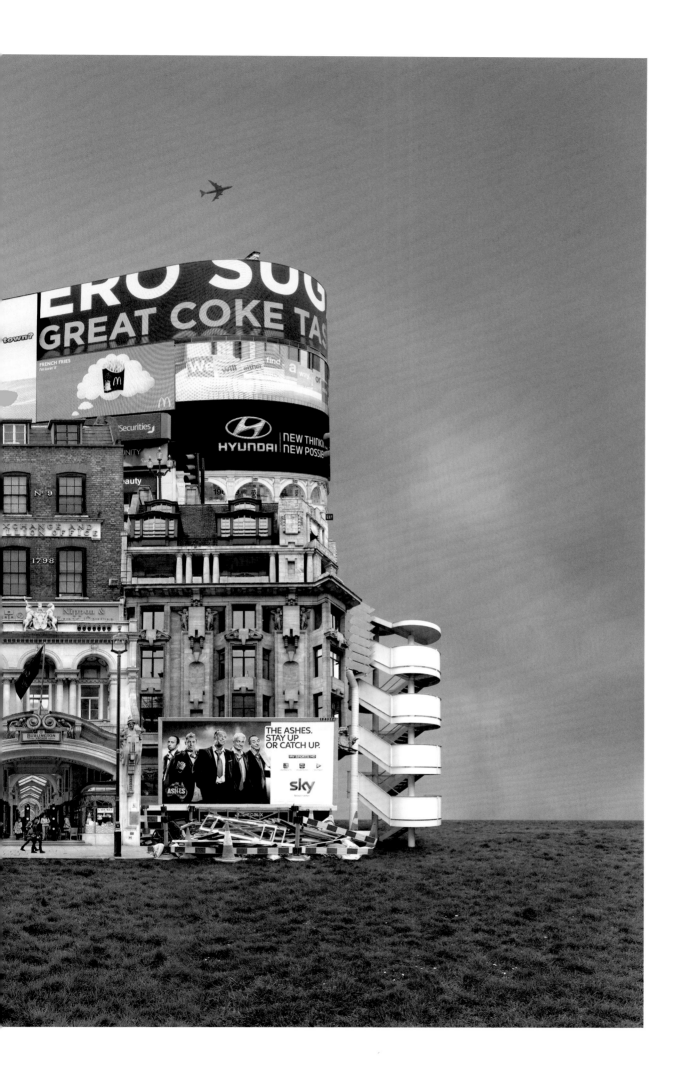

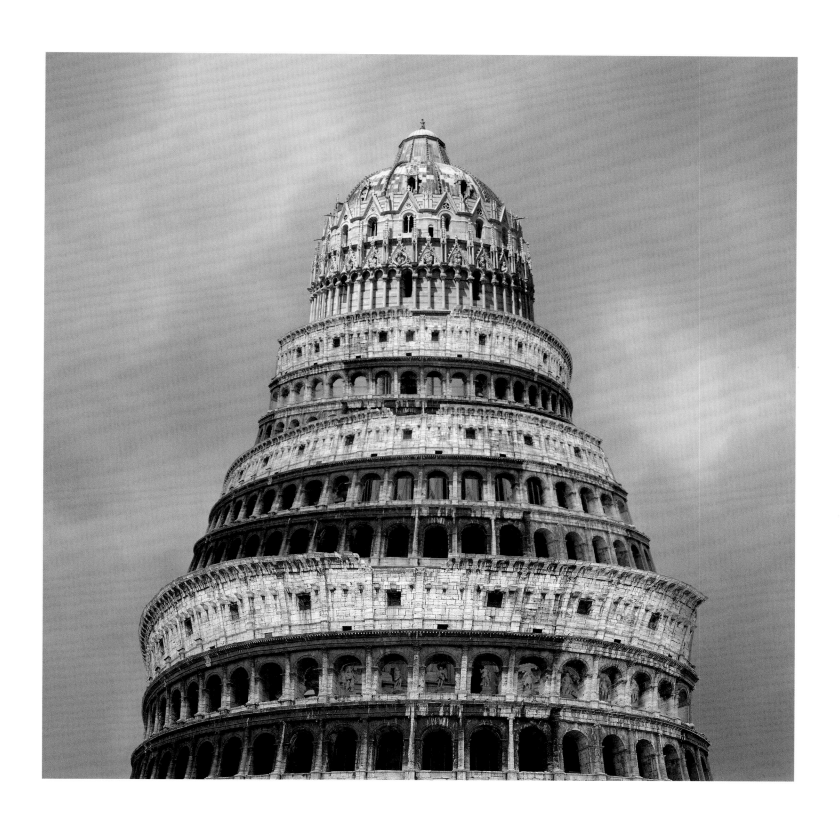

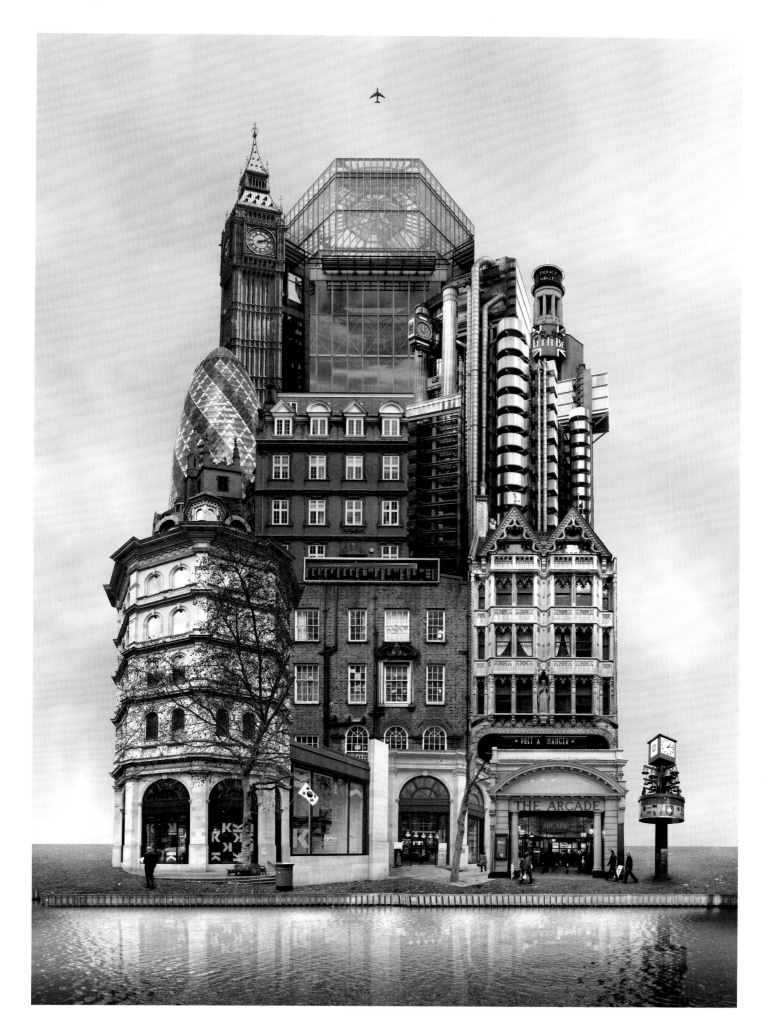

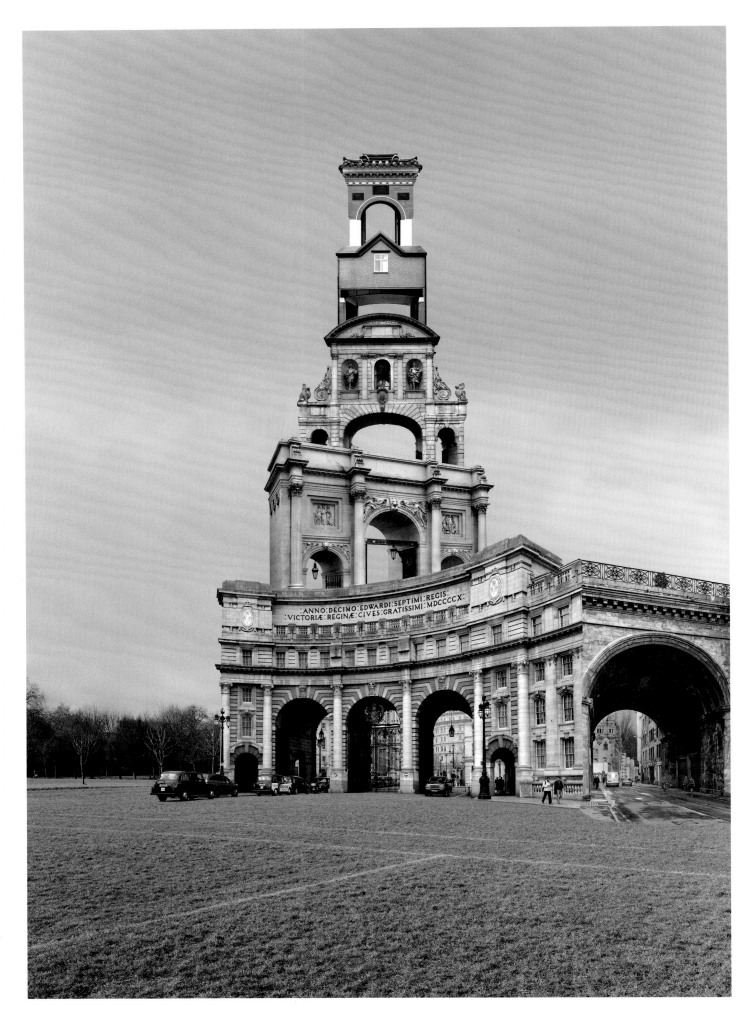

ANNO·DECIMO·EDWARDI·SEPTIMI·REGIS·
:VICTORIÆ·REGINÆ·CIVES·GRATISSIMI·MDCCCCX·

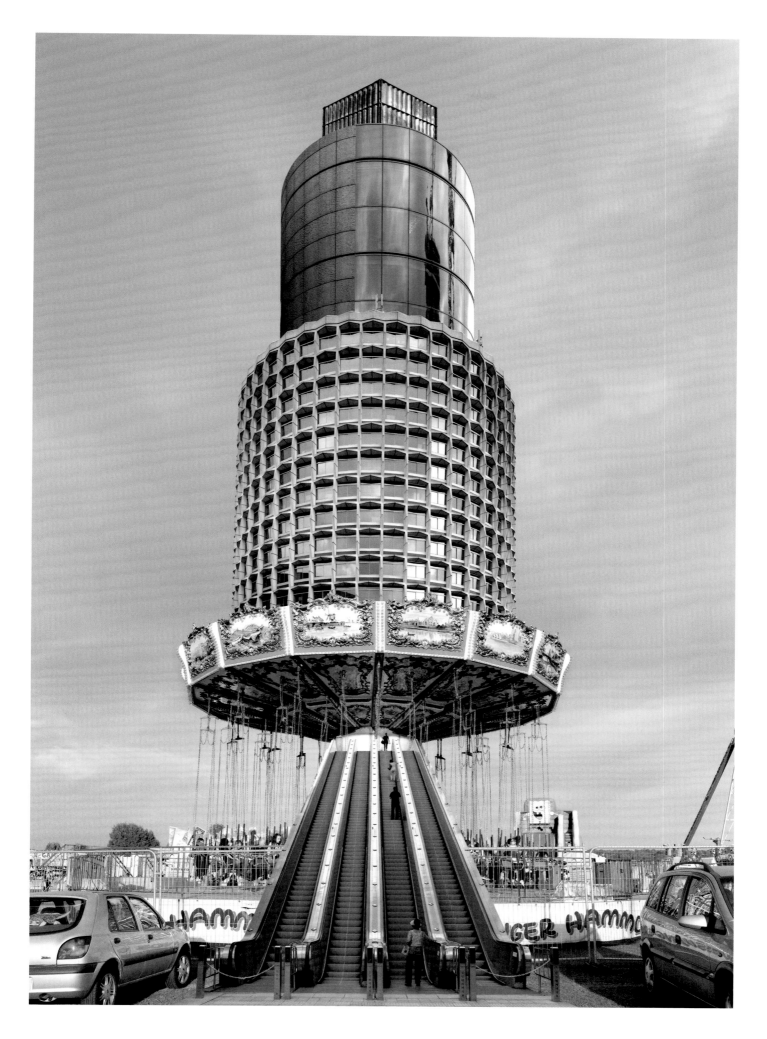

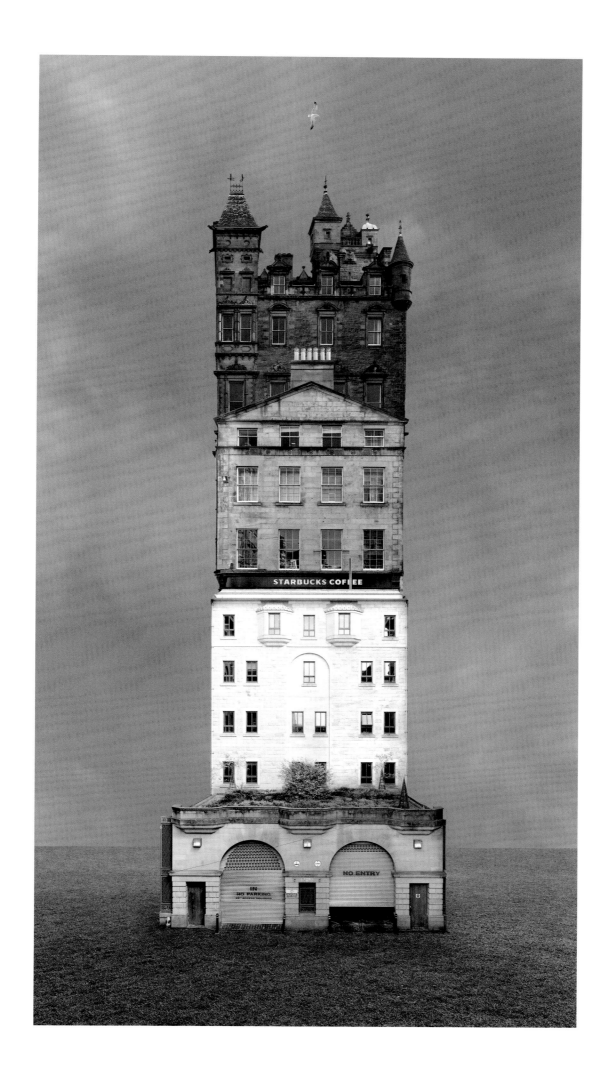

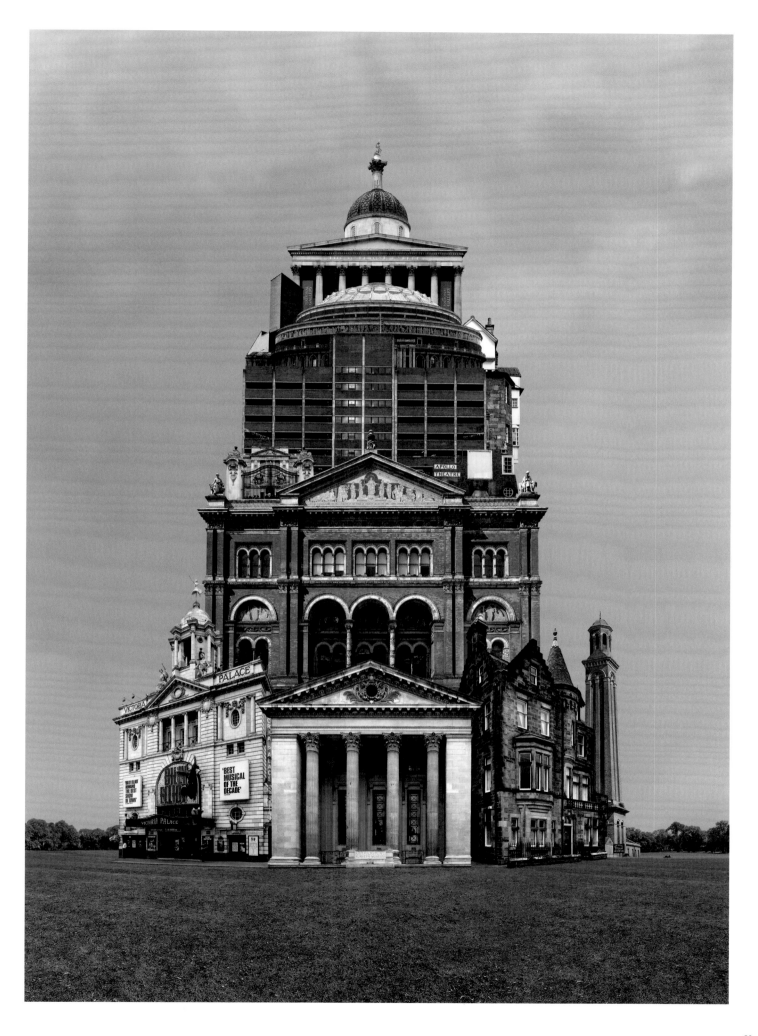

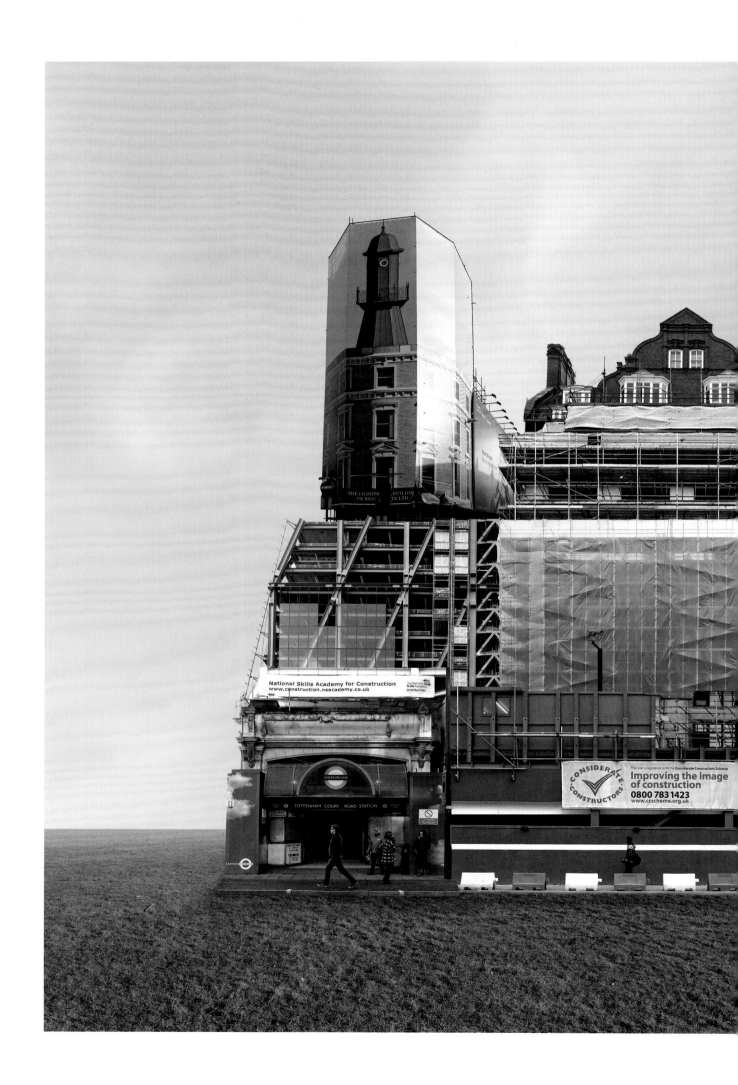

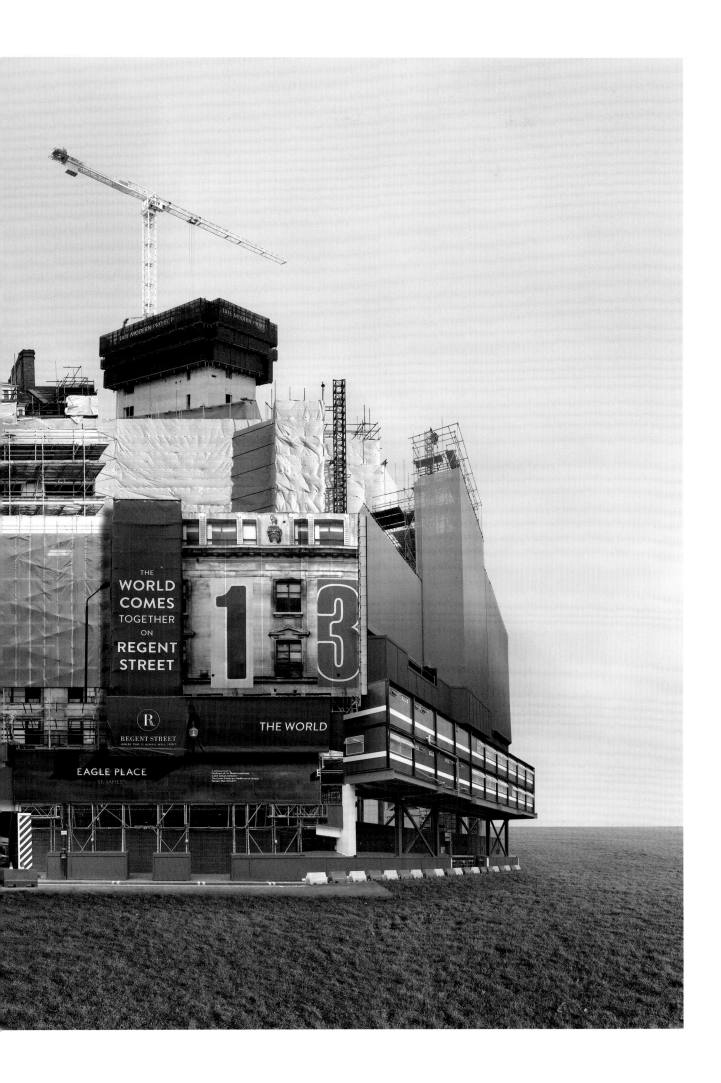

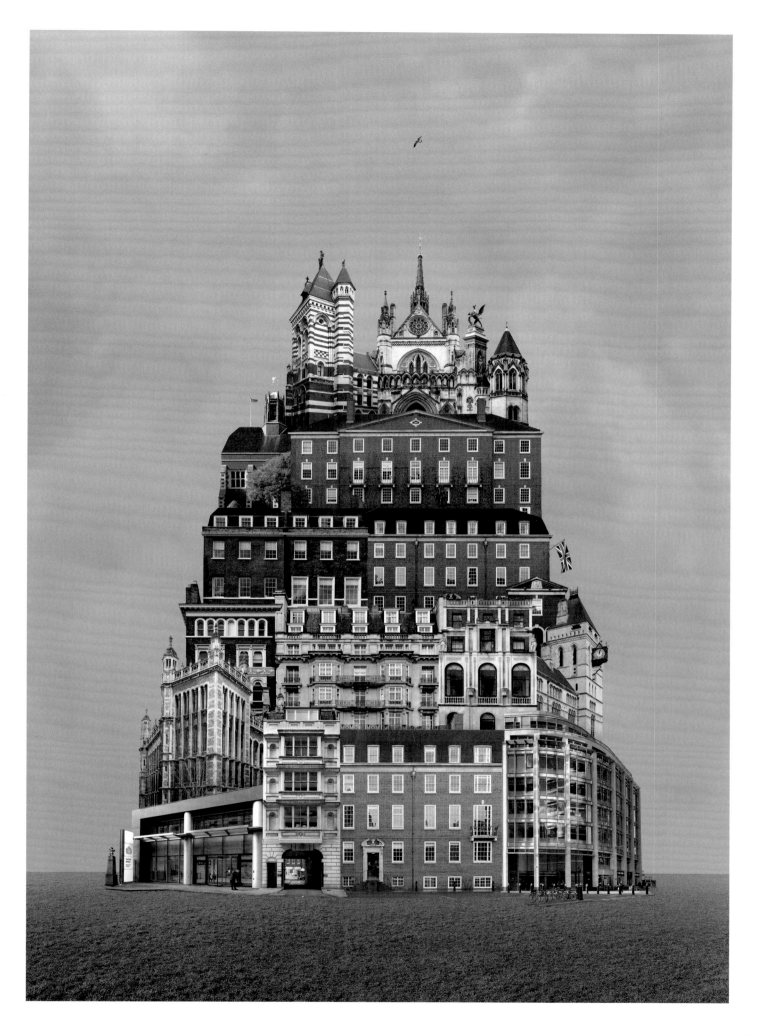

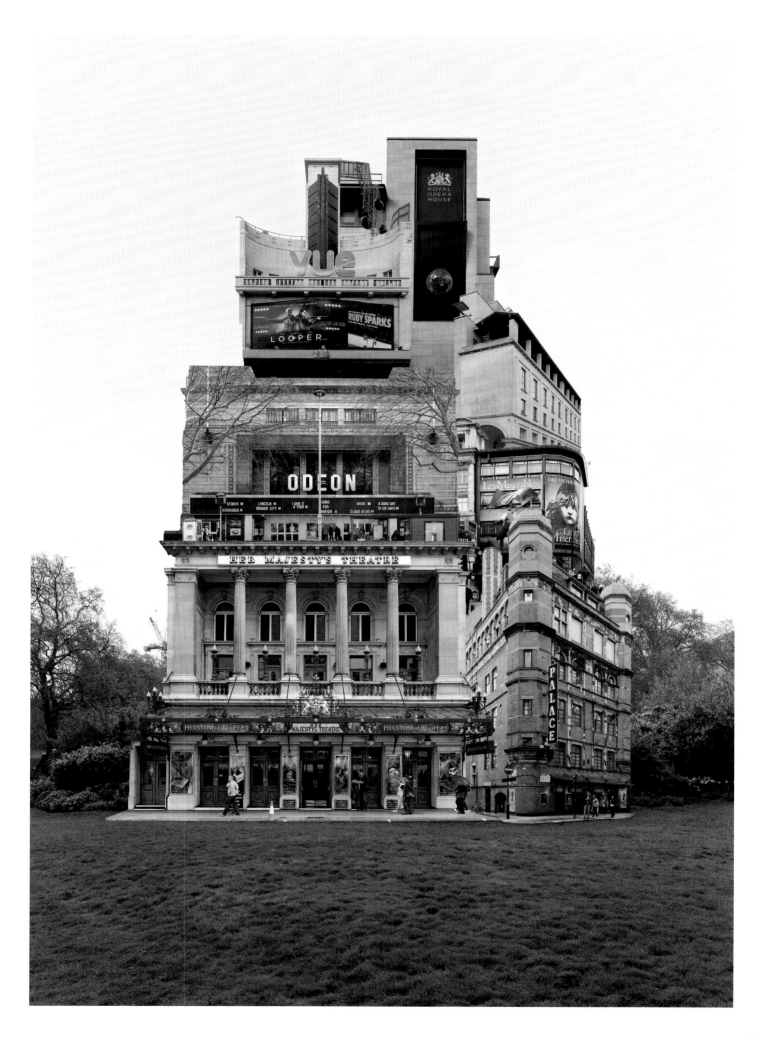

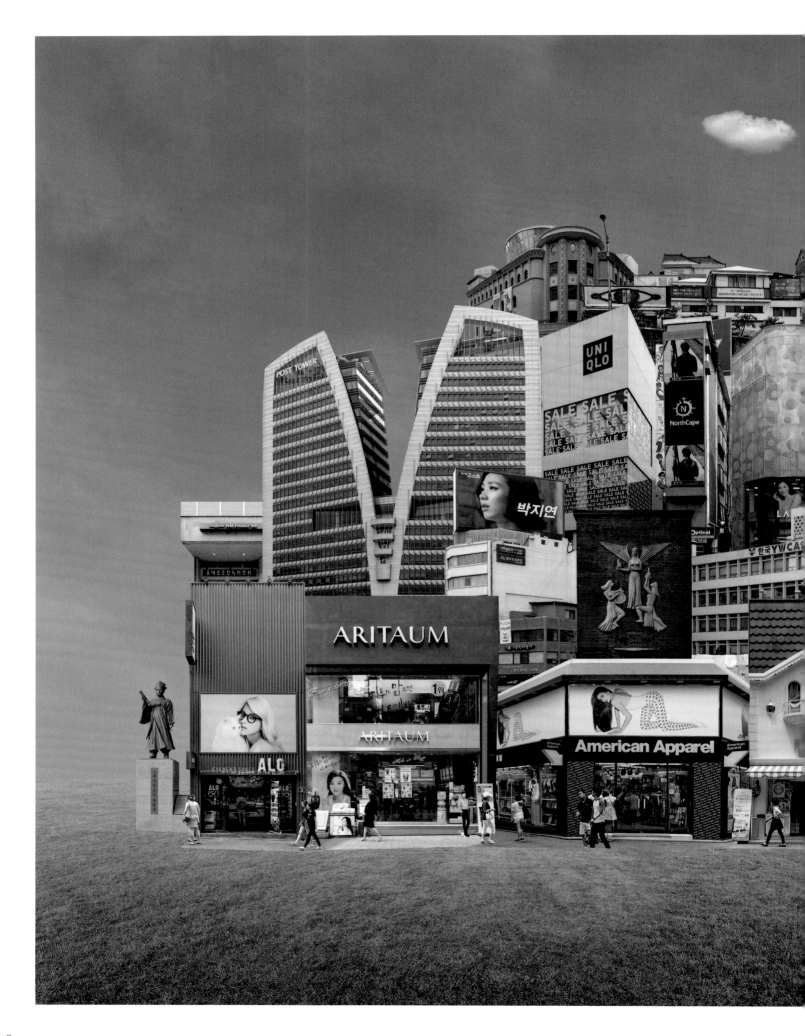

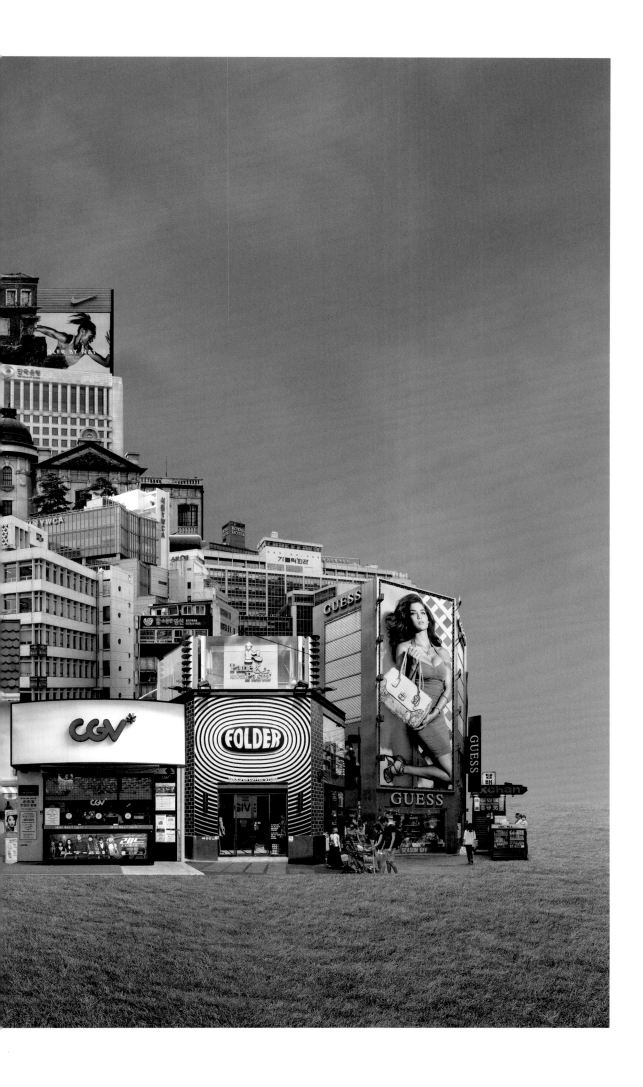

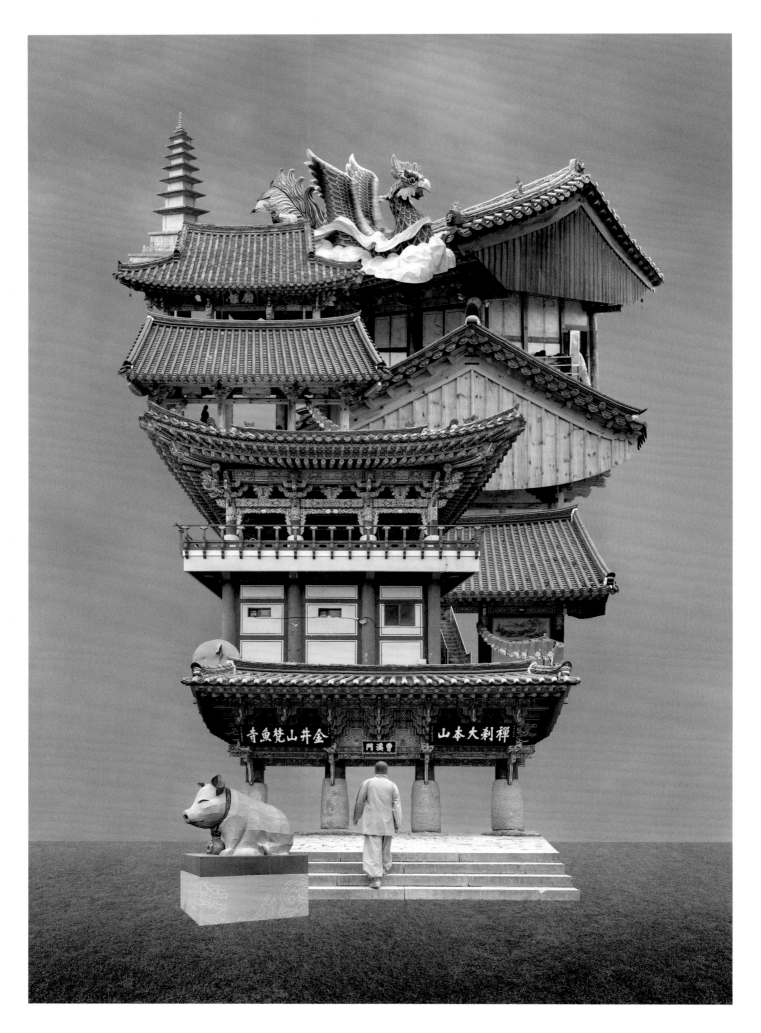

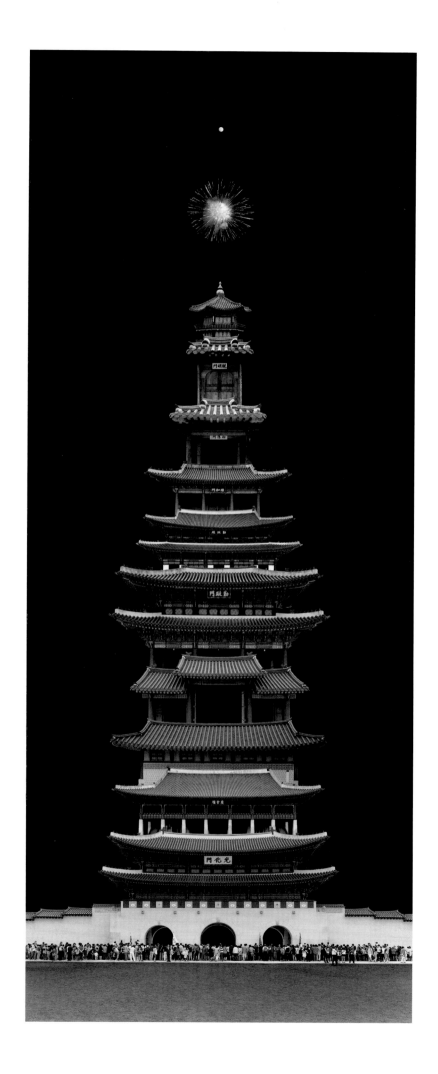

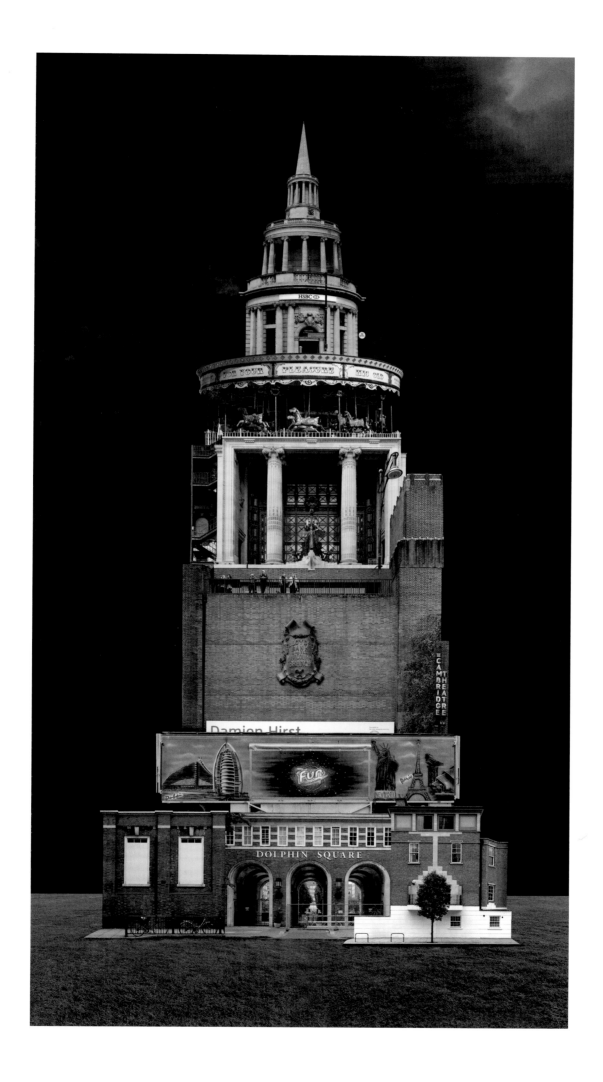

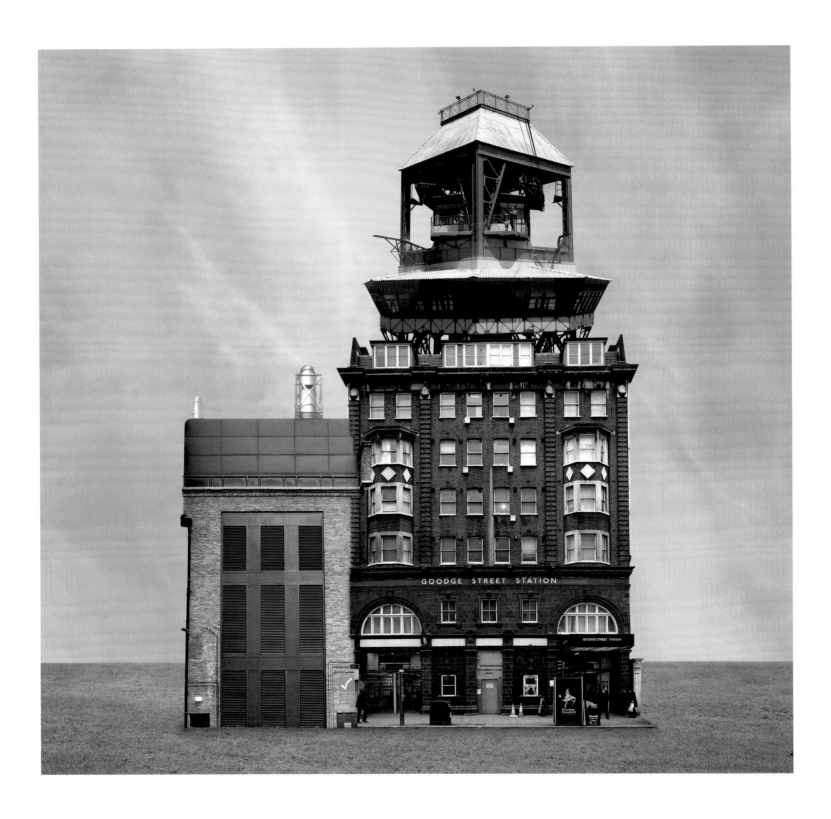

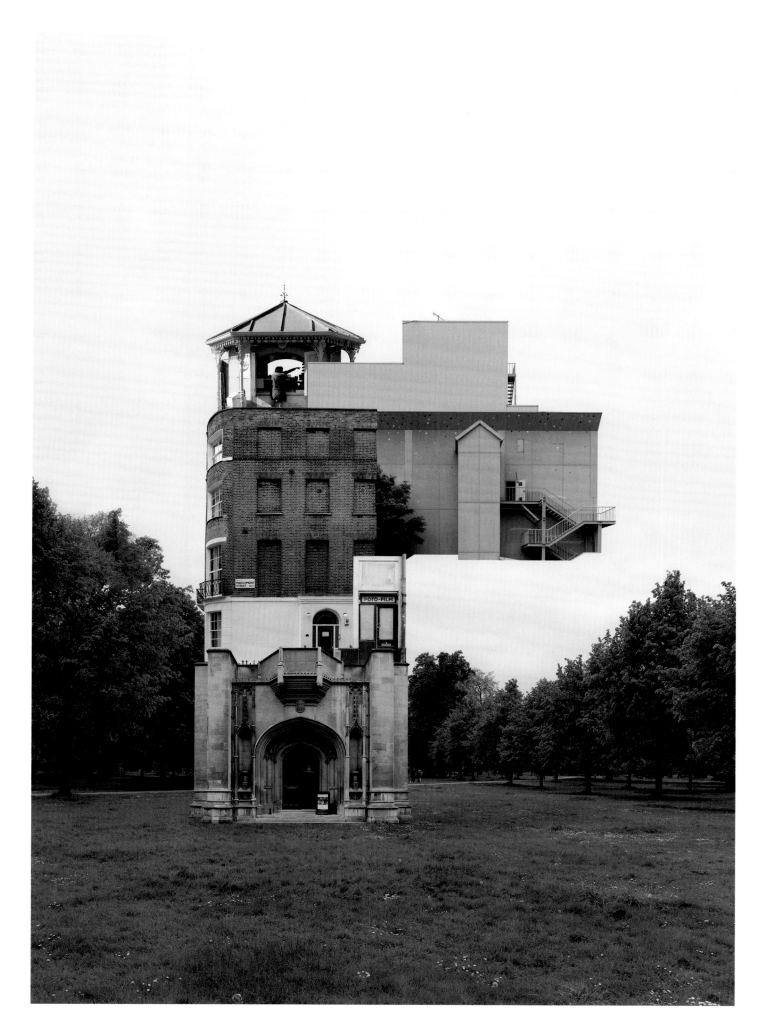

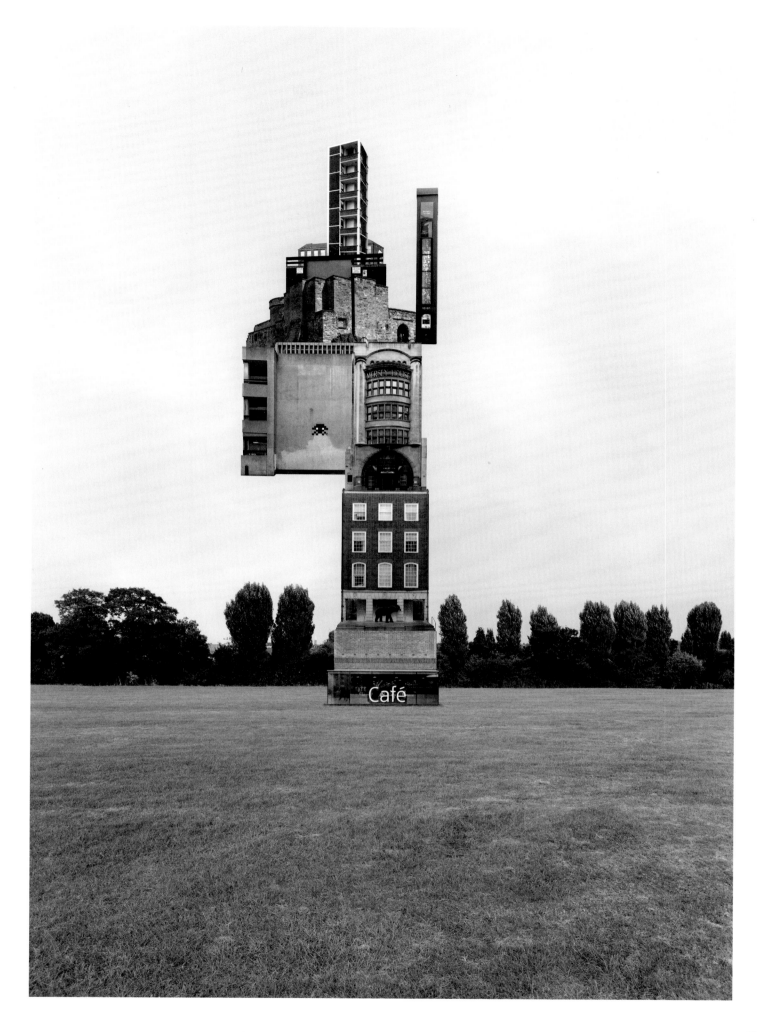

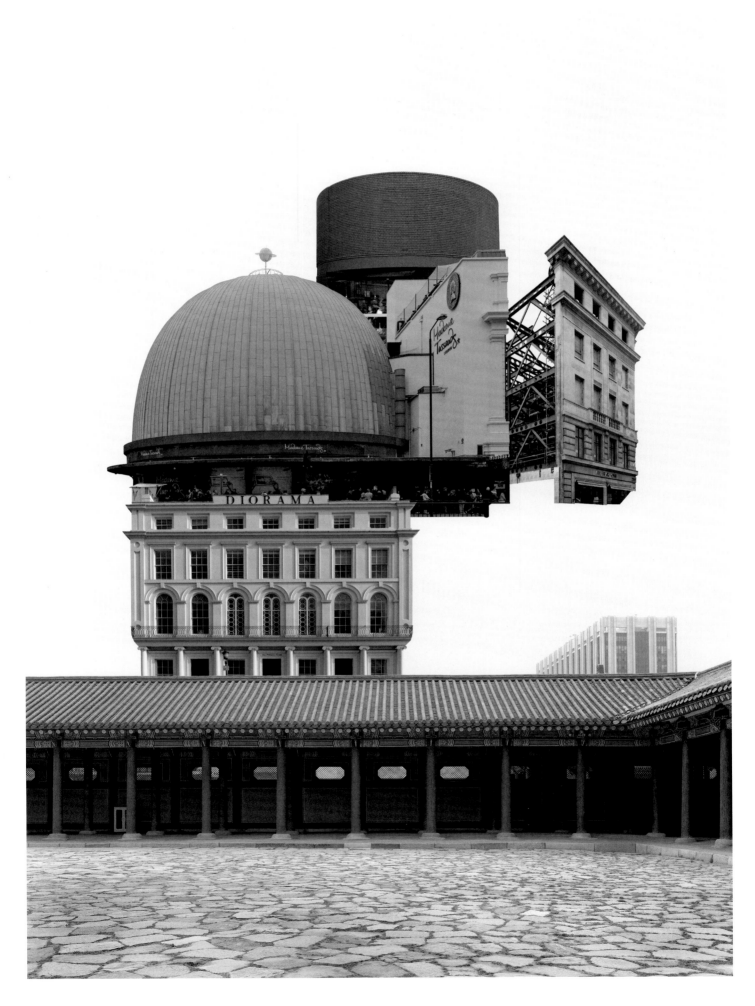

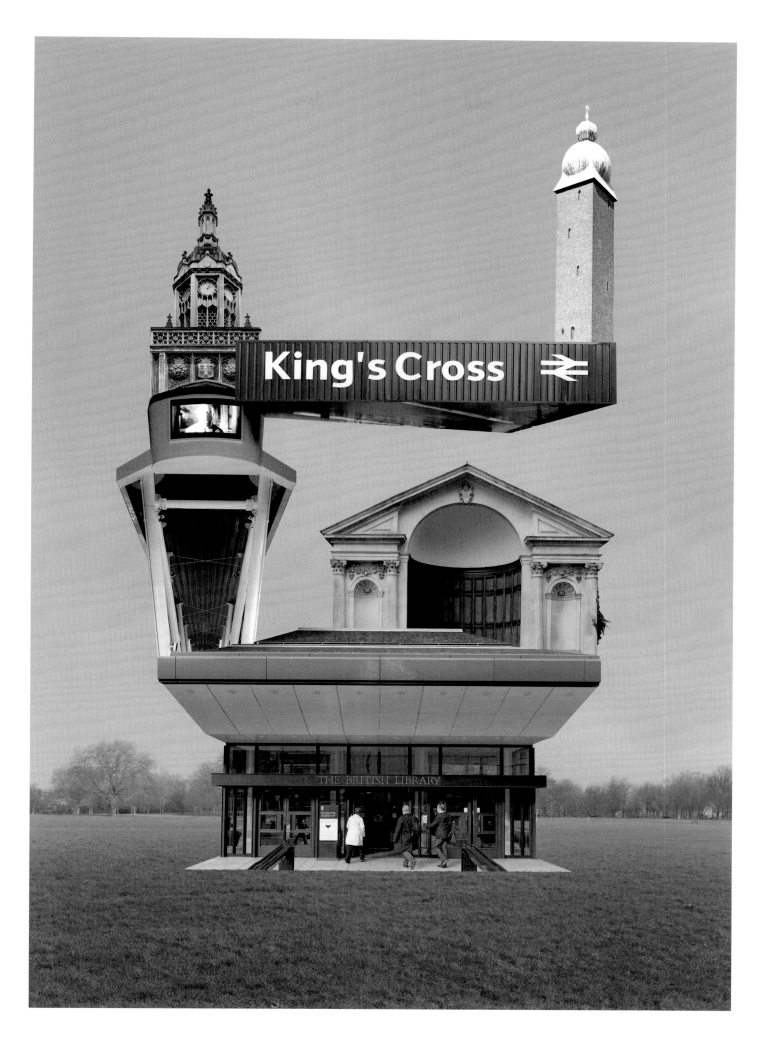

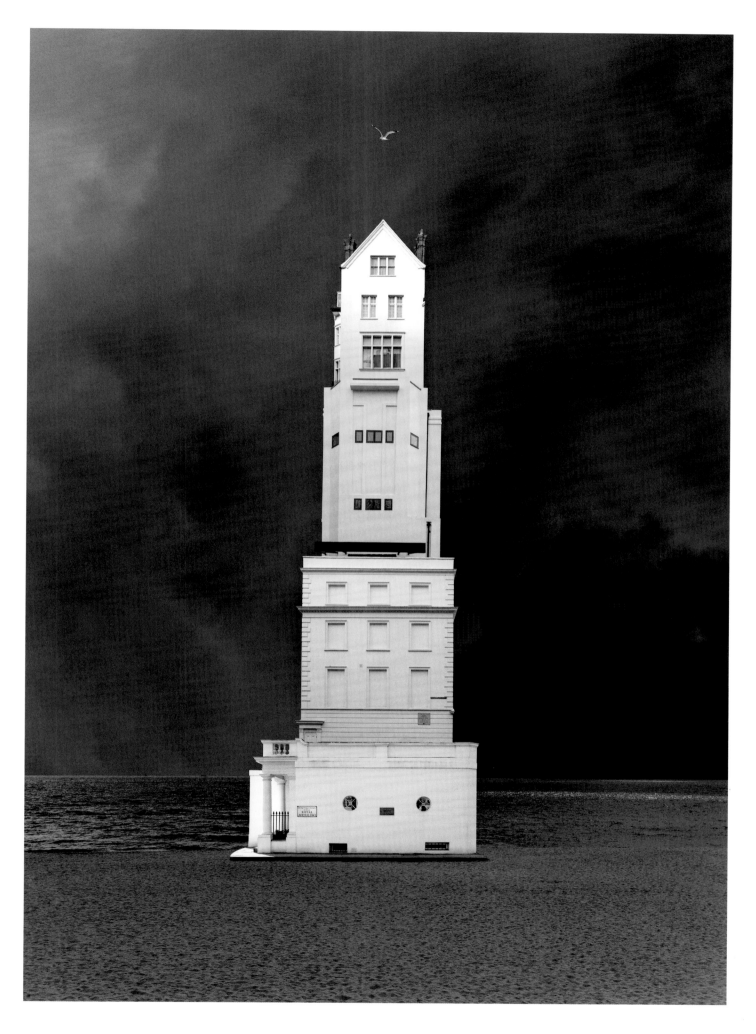

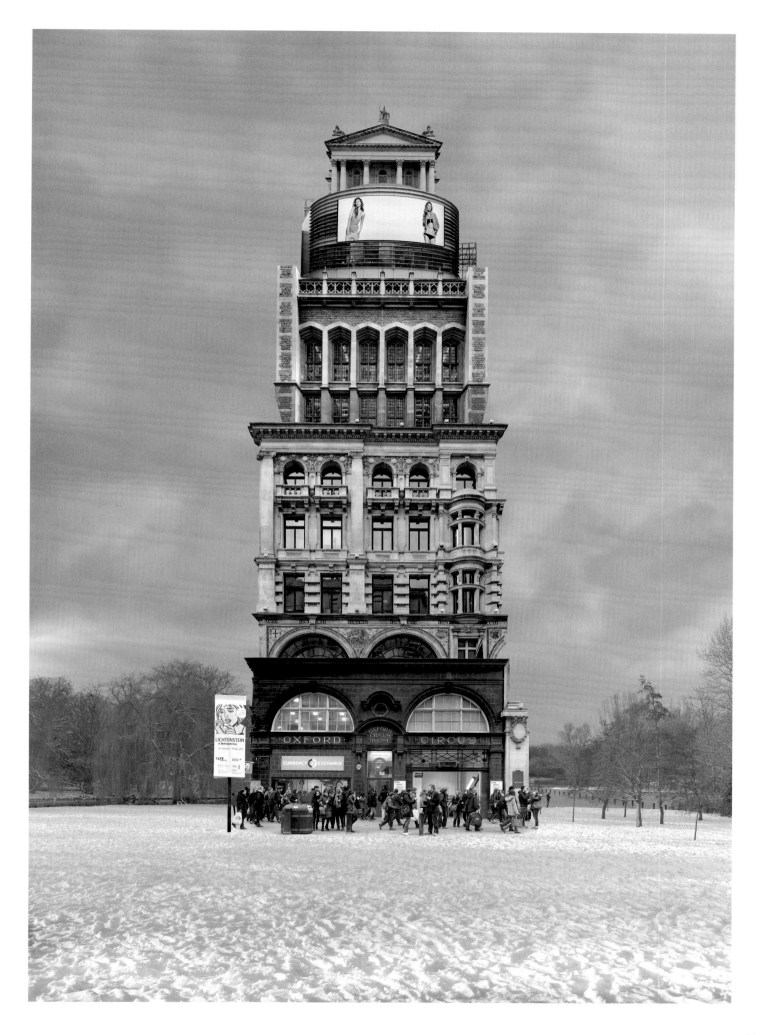

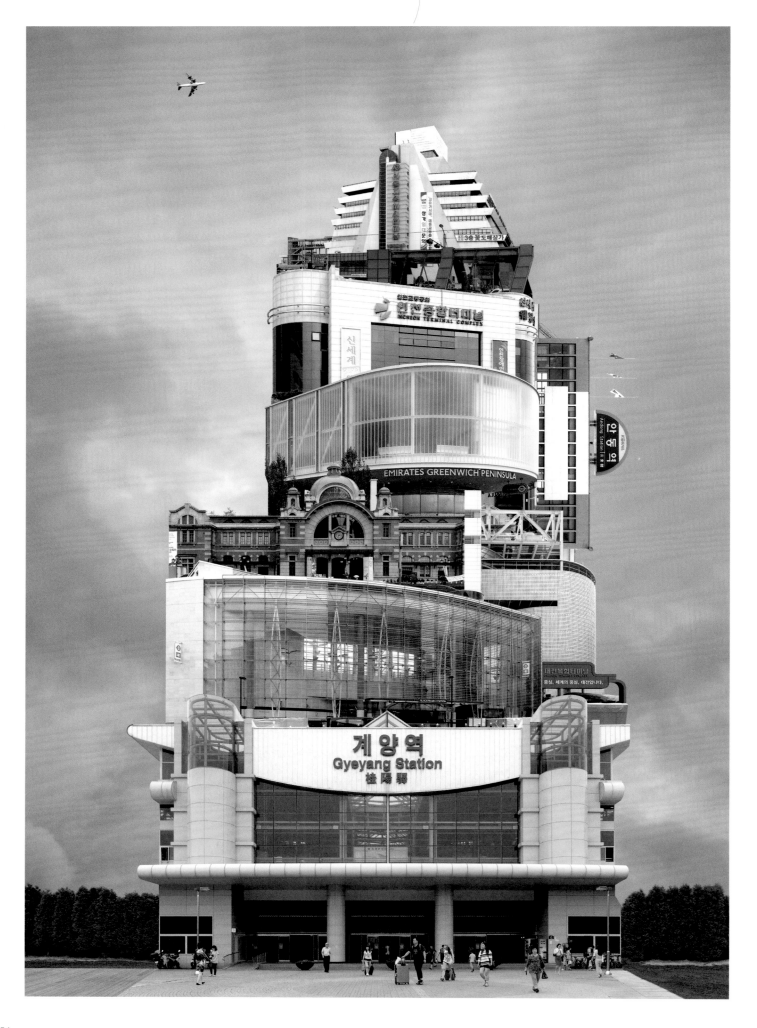

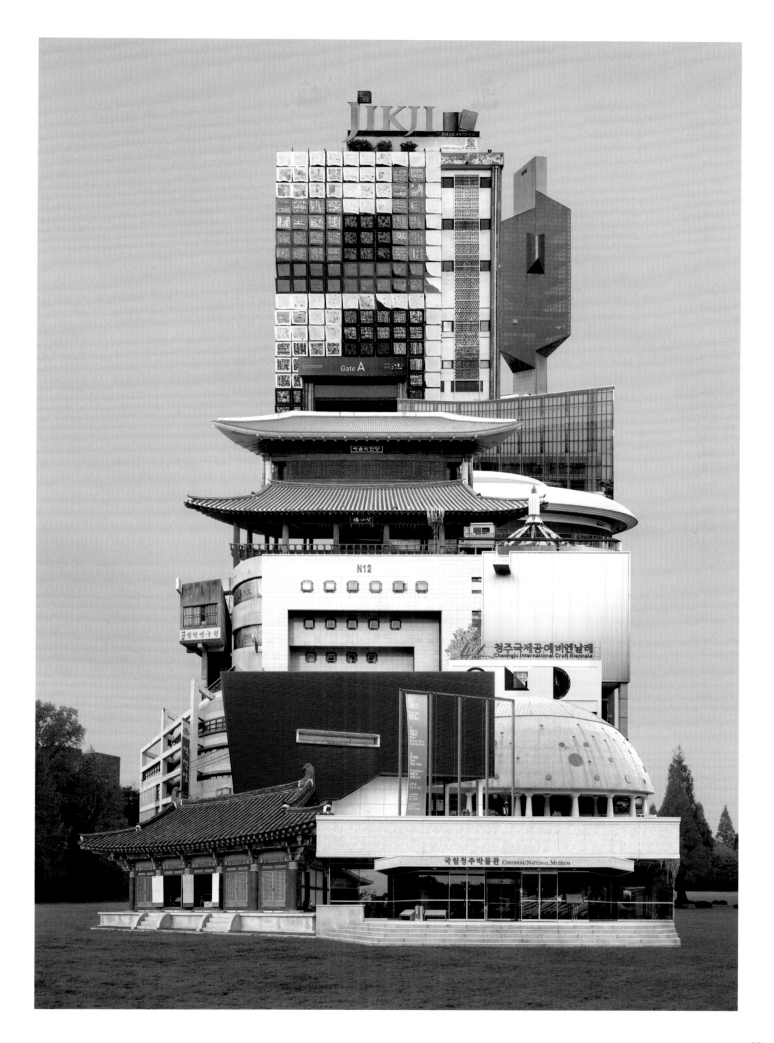

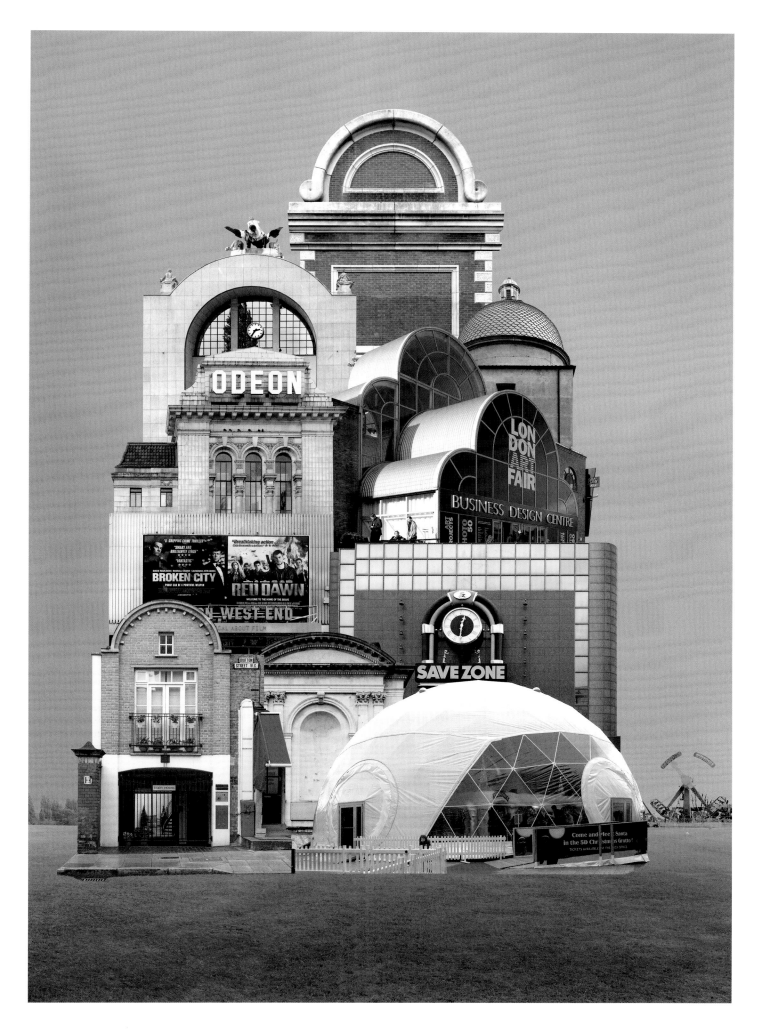

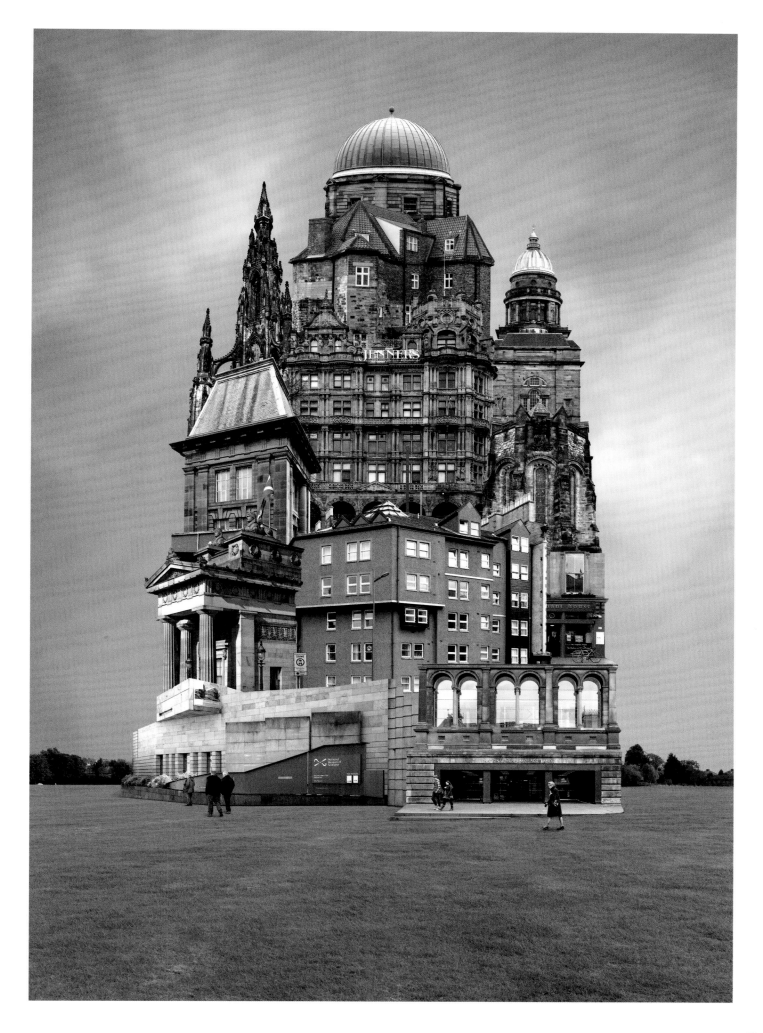

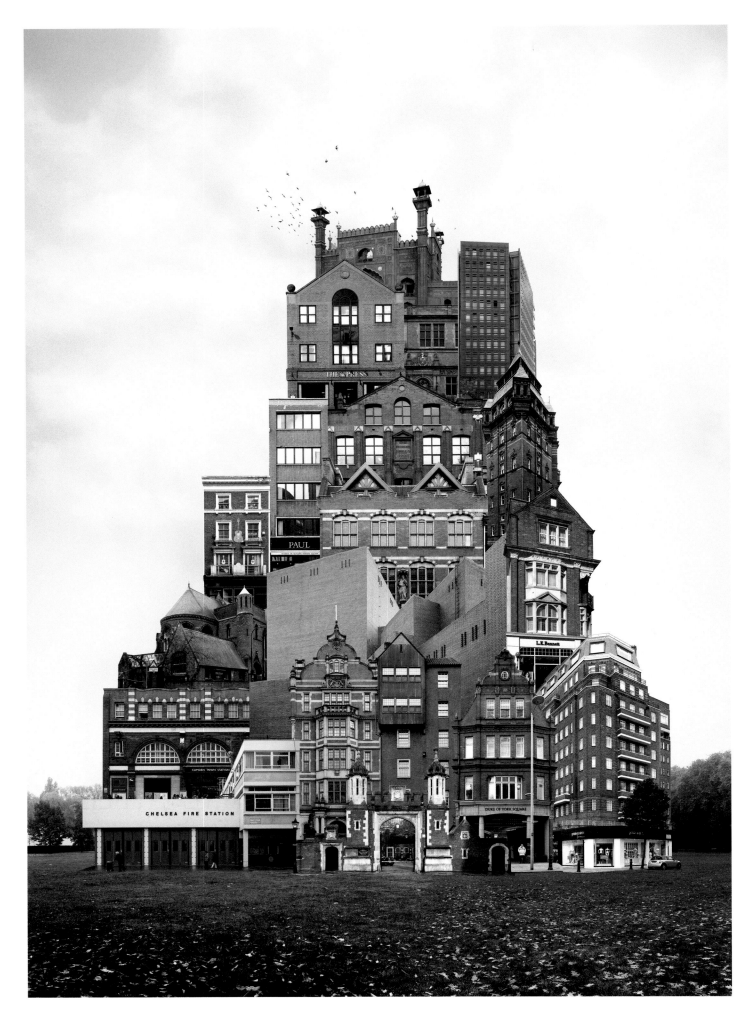

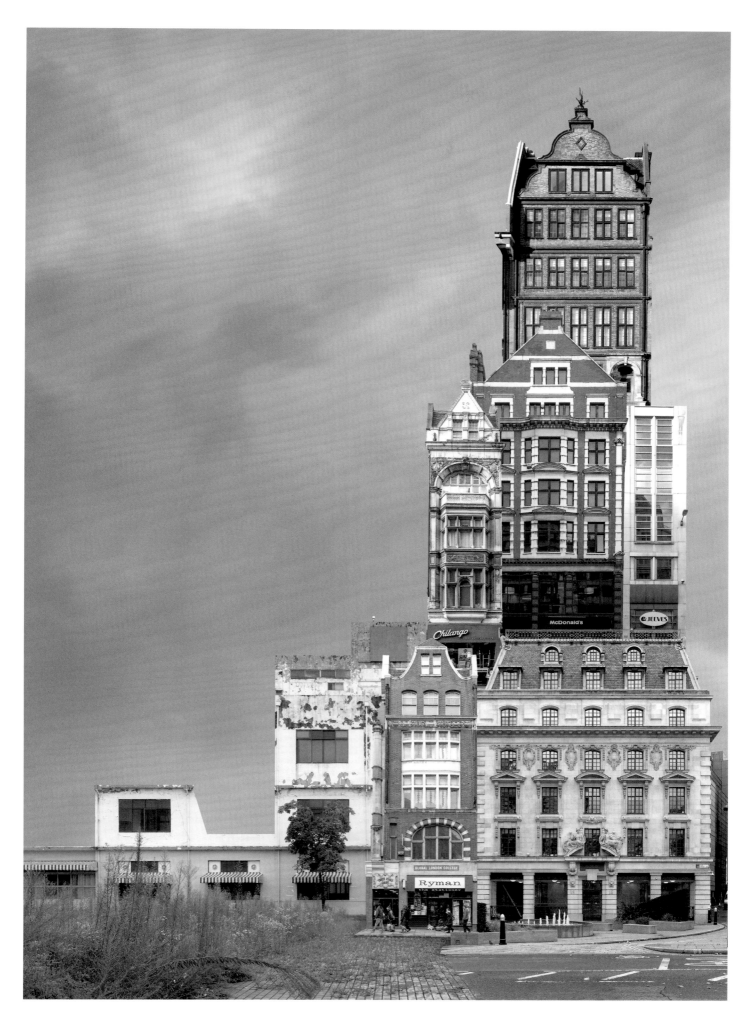

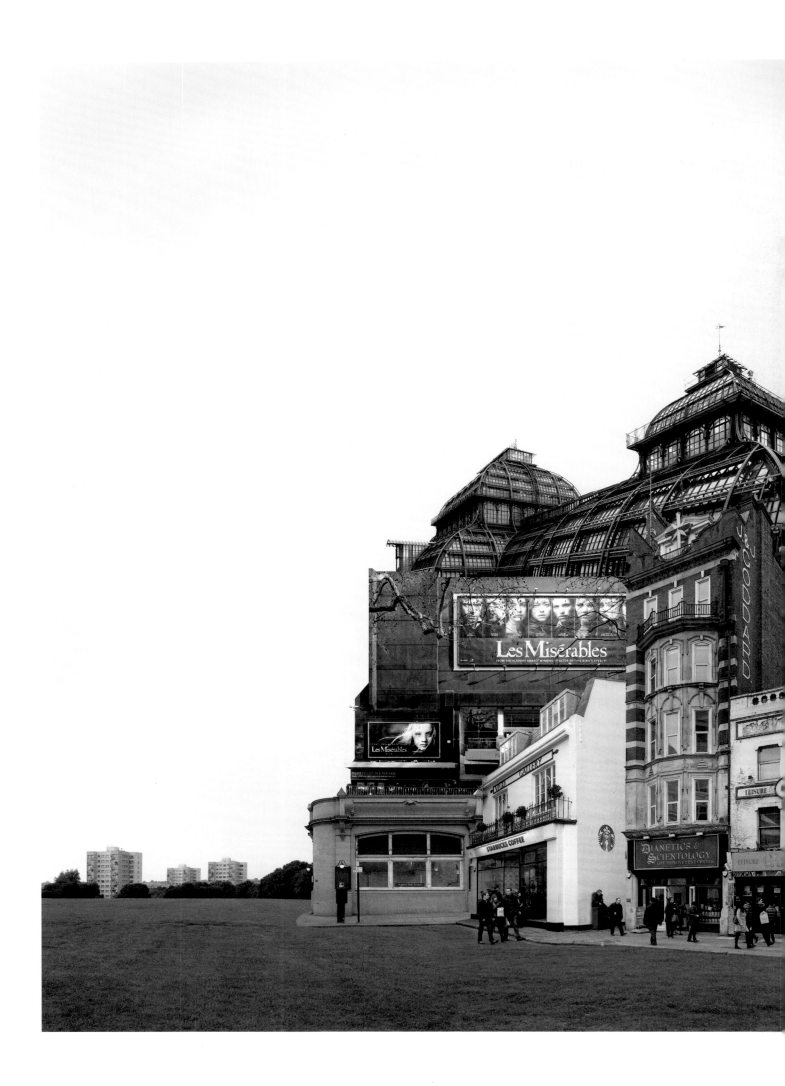

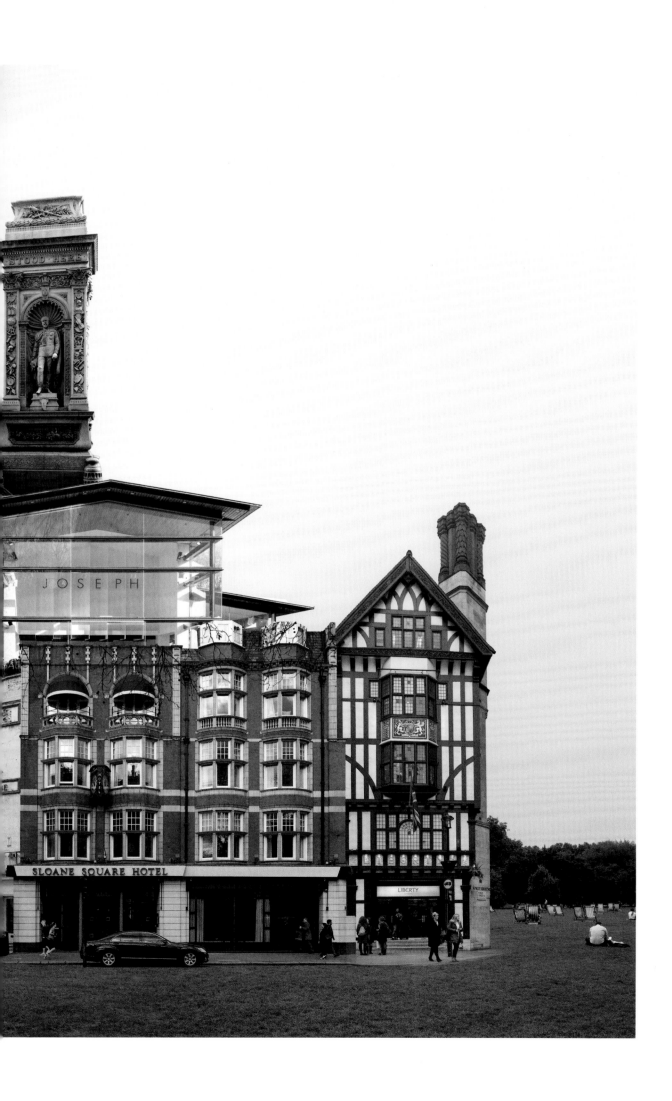

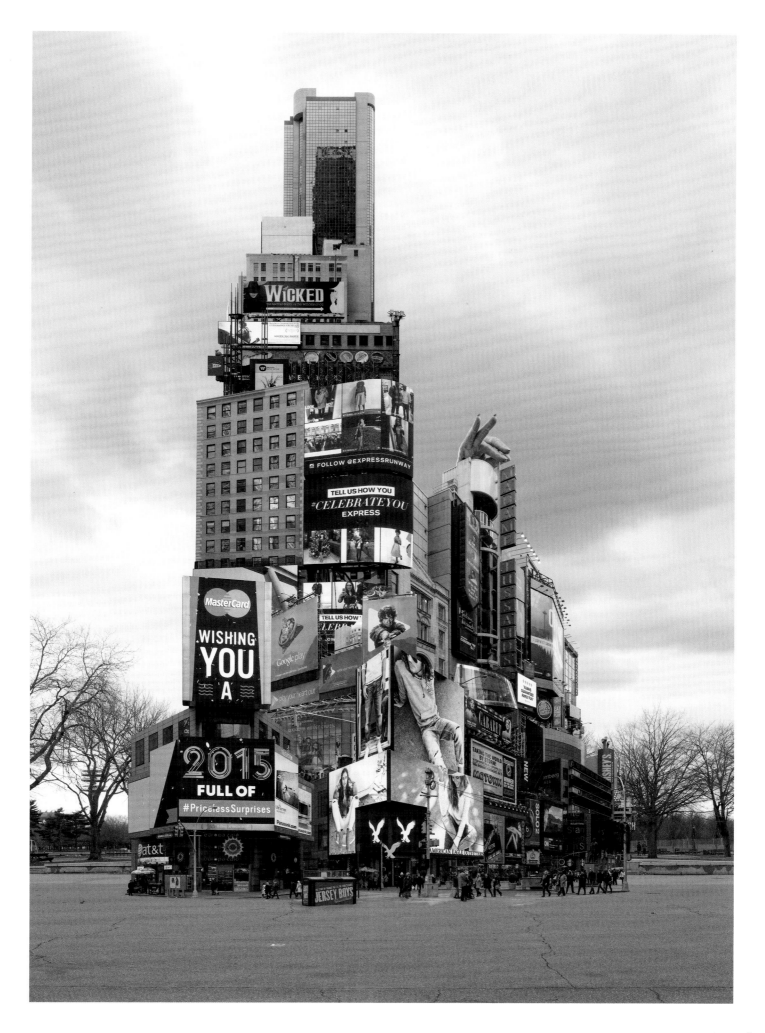

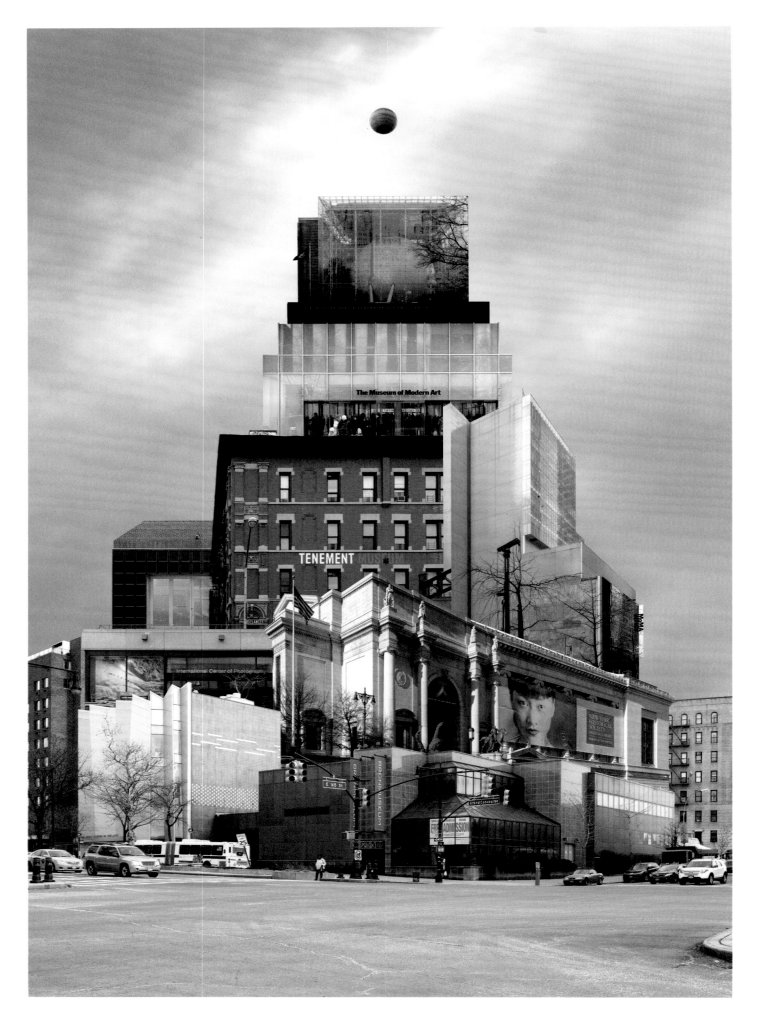

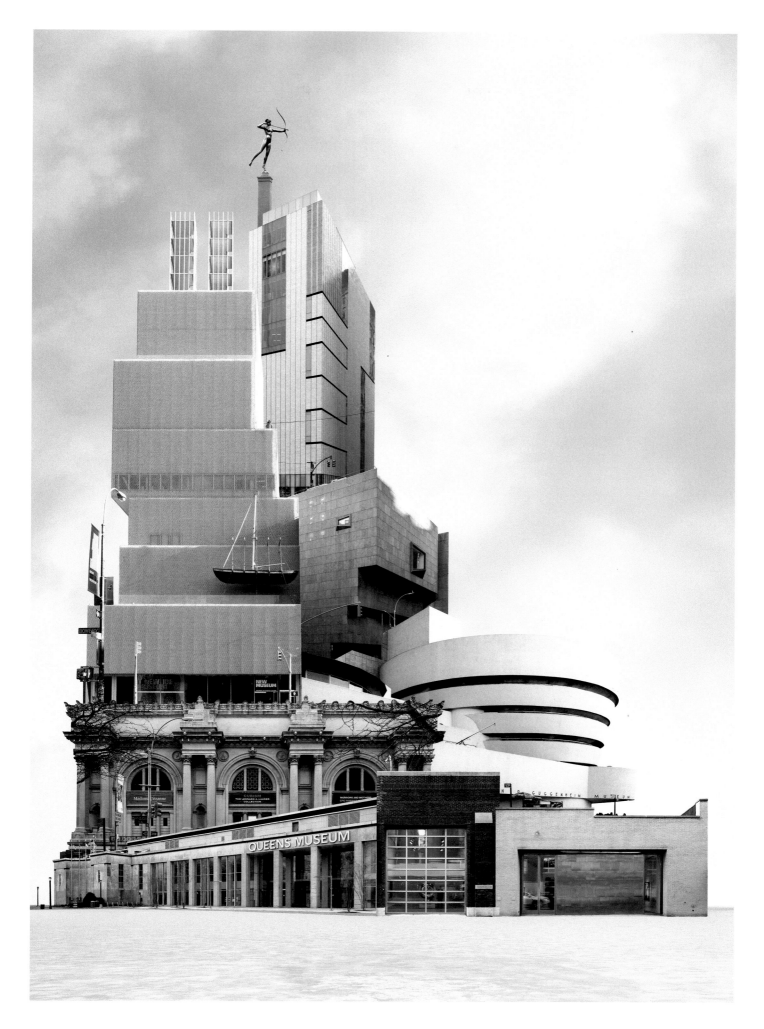

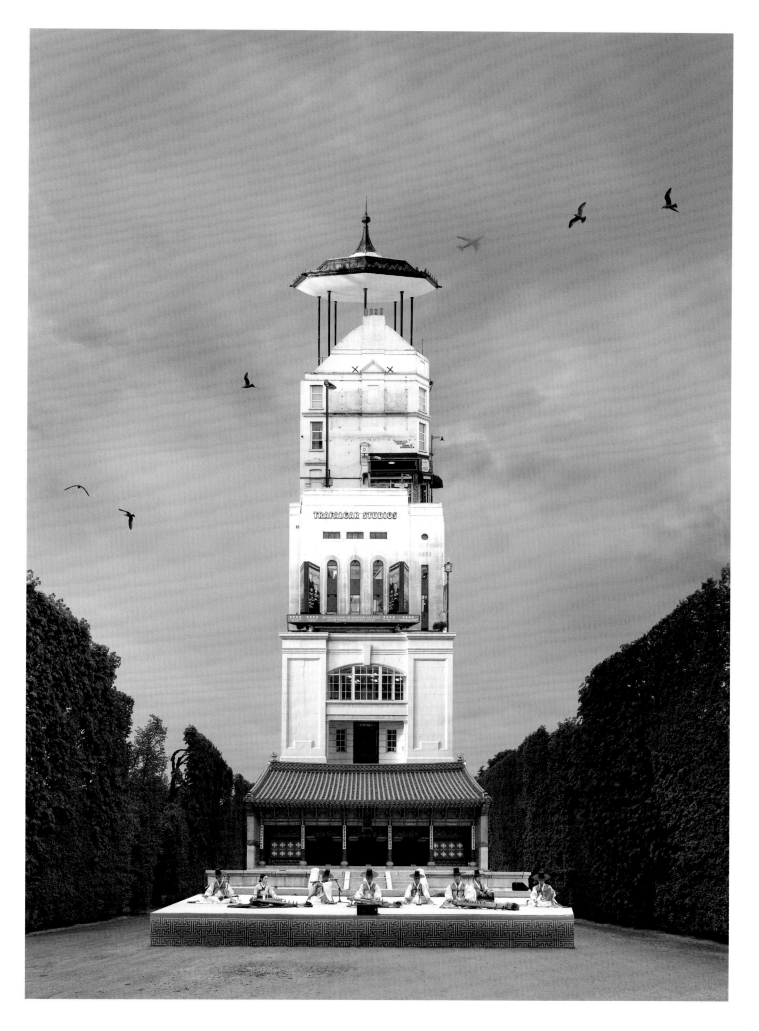

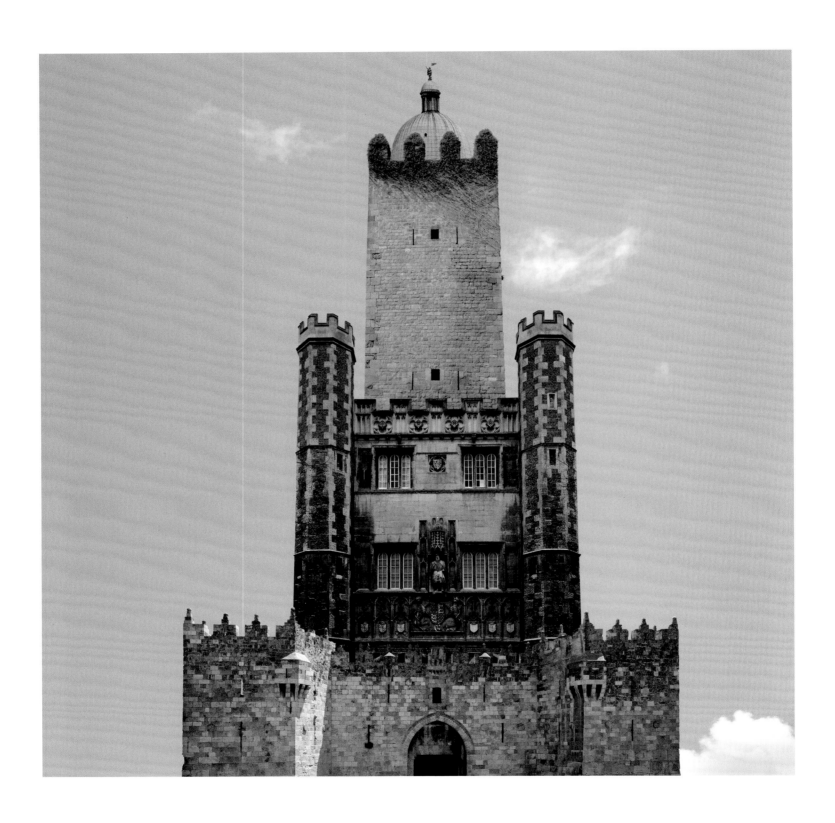

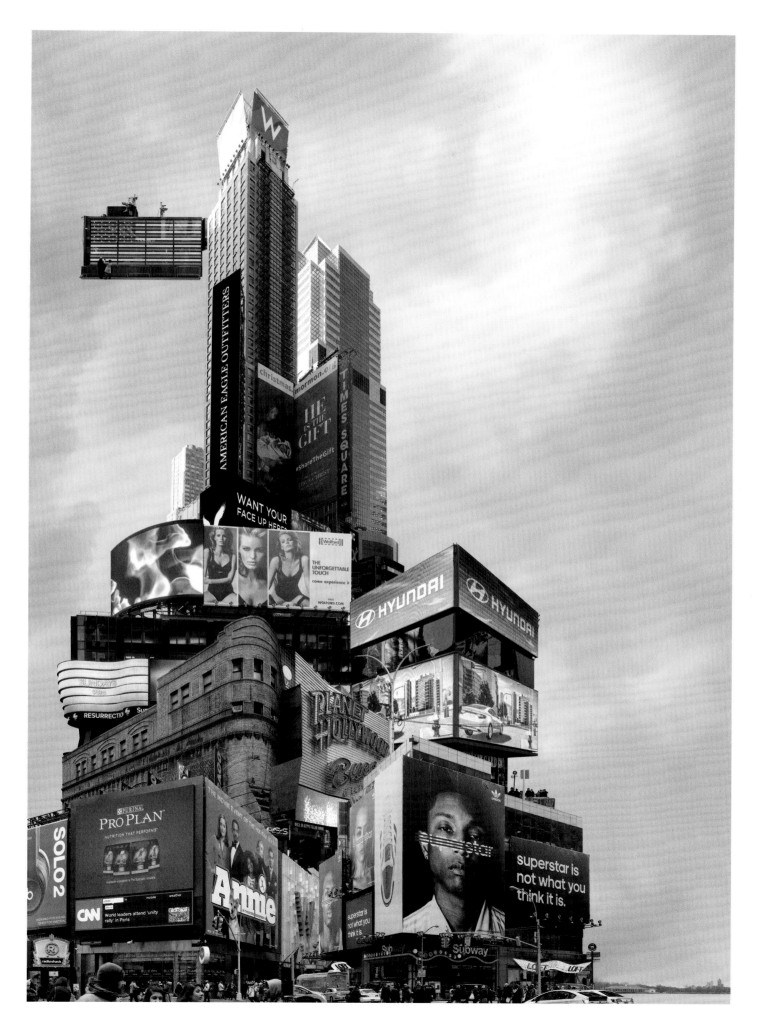

ARCHISCULPTURE

René Descartes viewed as beautiful the order and coherency of structures designed by a single architect; the purpose of the *Archisculpture* photo project, however, is to create architectural sculptures by collaging photographs of diverse architectural works from various architects. In this way, the *Archisculpture* photos are both similar and different to the organic romanticism of old cities built through the works of myriad architects, for they represent the artist's subjective interpretation and decisions regarding various architects' numerous designs. If a photograph has a *punctum* then clearly the architectural works used here will in certain ways be the artist's *punctum* and their assemblage will be the *Archisculpture* photo. These works may also locate and bring together structures with political, economic, or social significance, creating through the work's *studium* the illusion of a metropolis. Like collectors who arrange and classify their acquisitions with great care, artists analyze selected city fragments gathered from here and there and with them create their sculptures. What exist now as disparate structures are reborn as beautiful sculptures which retain their diachronic or synchronic histories, or else encompass it all. As the Russian film director Sergei Mikhailovich Eisenstein explained in relation to the montage technique, the collaging employed in this process creates through the collision of disparate elements stories that before remained beneath the surface. In essence, however, it is a photograph of a nonexistent, architectural sculpture.

Beomsik WON

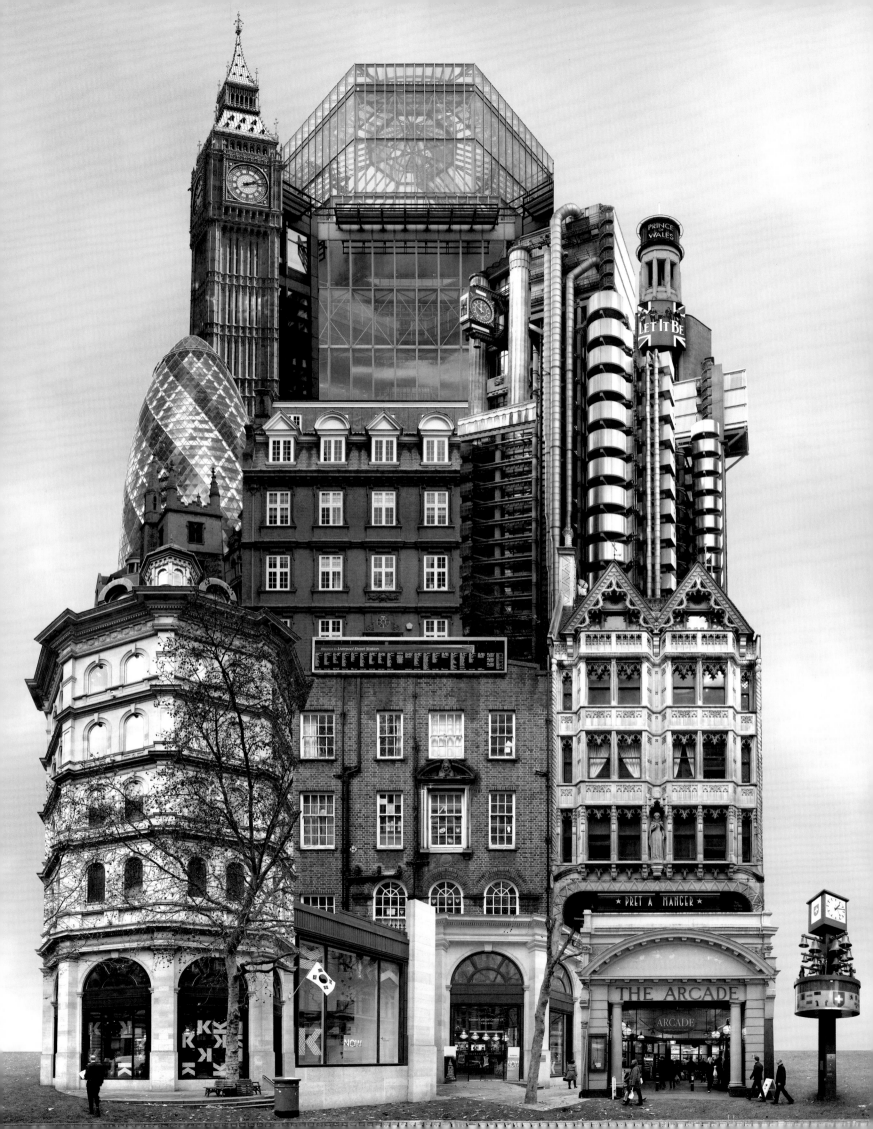

Archisculpture 001, 2010
100 × 100 or 30 × 30 cm
archival pigment print

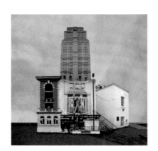

Archisculpture 002, 2010
50 × 50 cm
archival pigment print

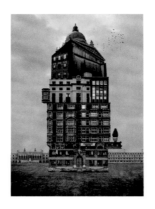

Archisculpture 008, 2012
100 × 70 or 171 × 120 cm
archival pigment print

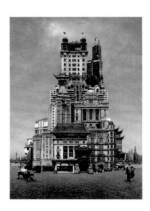

Archisculpture 017, 2013
100 × 70 or 171 × 120 cm
archival pigment print

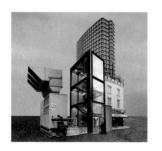

Archisculpture 003, 2010
50 × 50 cm
archival pigment print

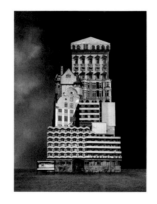

Archisculpture 009, 2012
100 × 70 or 171 × 120 cm
archival pigment print

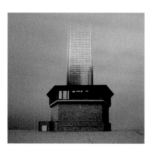

Archisculpture 005, 2011
50 × 50 cm
archival pigment print

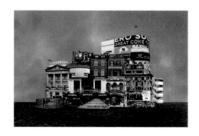

Archisculpture 010, 2012
70 × 100 or 120 × 171 cm
archival pigment print

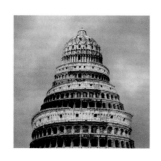

Archisculpture 006, 2011,
50 × 50 cm
archival pigment print

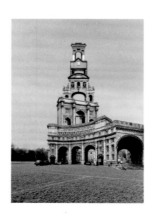

Archisculpture 013, 2012
100 × 70 or 171 × 120 cm
archival pigment print

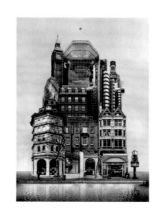

Archisculpture 030, 2014
70 × 49 or 100 × 70 or 142 × 100 cm
archival pigment print

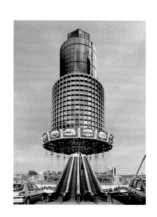

Archisculpture 028, 2014
70 × 49 or 100 × 70 or 142 × 100 cm
archival pigment print

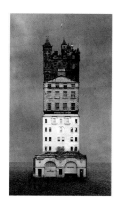

Archisculpture 014, 2013
46 × 25 or 135 × 73 cm
archival pigment print

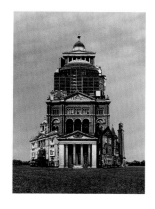

Archisculpture 011, 2012
100 × 70 or 171 × 120 cm
archival pigment print

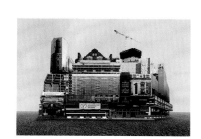

Archisculpture 015, 2013
70 × 100 or 120 × 171 cm
archival pigment print

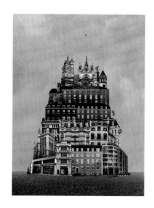

Archisculpture 016, 2013
100 × 70 or 171 × 120 cm
archival pigment print

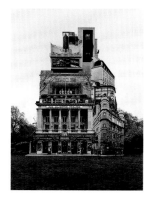

Archisculpture 024, 2014
70 × 49 or 100 × 70 or 142 × 100 cm
archival pigment print

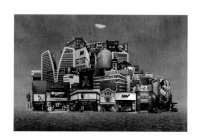

Archisculpture 019, 2014
70 × 100 or 120 × 171 cm
archival pigment print

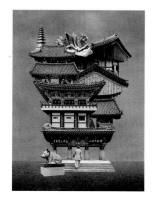

Archisculpture 020, 2014
100 × 70 or 171 × 120 cm
archival pigment print

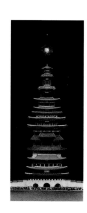

Archisculpture 018, 2013
100 × 38 or 171 × 65 cm
archival pigment print

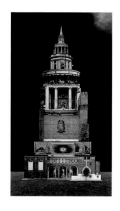

Archisculpture 012, 2012
100 × 53 or 171 × 91 cm
archival pigment print

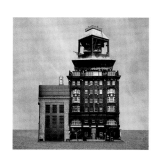

Archisculpture 004, 2011
50 × 50 cm
archival pigment print

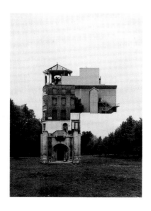

Archisculpture 021, 2014
100 × 70 cm
archival pigment print

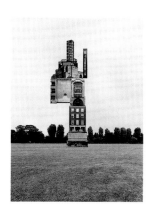

Archisculpture 026, 2014
100 × 70 or 171 × 120 cm
archival pigment print

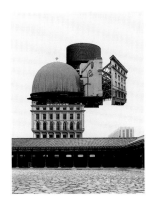

Archisculpture 023, 2014
100 × 70 cm
archival pigment print

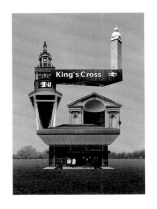

Archisculpture 022, 2014
100 × 70 cm
archival pigment print

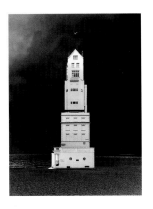

Archisculpture 025, 2014
46 × 32 or 142 × 100 cm
archival pigment print

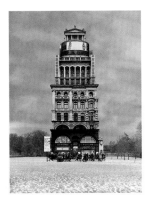

Archisculpture 027, 2014
70 × 49 or 100 × 70 or 142 × 100 cm
archival pigment print

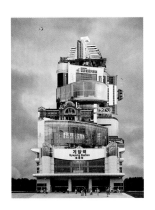

Archisculpture 032, 2014
100 × 70 or 171 × 120 cm
archival pigment print

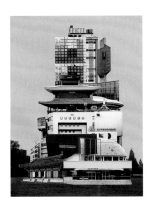

Archisculpture 041, 2015
100 × 70 or 171 × 120 cm
archival pigment print

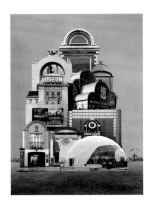

Archisculpture 033, 2014
46 × 32 or 142 × 100 cm
archival pigment print

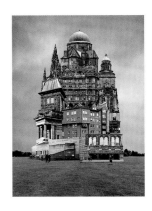

Archisculpture 034, 2015
100 × 70 or 171 × 120 cm
archival pigment print

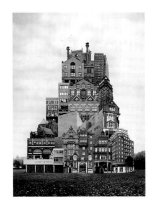

Archisculpture 038, 2014
100 × 70 or 171 × 120 cm
archival pigment print

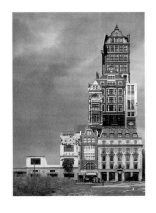

Archisculpture 035, 2015
100 × 70 or 171 × 120 cm
archival pigment print

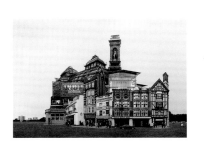

Archisculpture 040, 2014
70 × 100 or 120 × 171 cm
archival pigment print

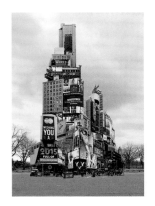

Archisculpture 044, 2015
100 × 70 or 171 × 120 cm
archival pigment print

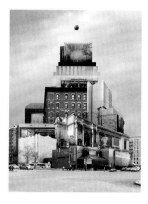

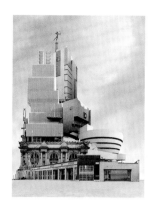

Archisculpture 043, 2015
100 × 70 or 171 × 120 cm
archival pigment print

Archisculpture 042, 2015
46 × 32 or 142 × 100 cm
archival pigment print

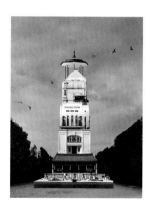

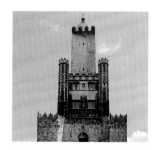

Archisculpture 031, 2014
100 × 70 or 171 × 120 cm
archival pigment print

Archisculpture 007, 2011
50 × 50 cm
archival pigment print

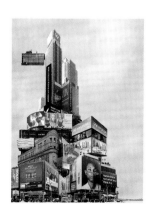

Archisculpture 045, 2015
100 × 70 or 171 × 120 cm
archival pigment print

BEOMSIK WON

was born in Wonju, South Korea in 1972

2014 Doctoral student, Department of Photography,
 Hongik University, Seoul, Korea
2012 Master of Fine Arts, Department of Fine Art Media,
 Slade School of Fine Art, University College of London, UK
2008 Master of Fine Arts, Department of Photography,
 Hongik University, Seoul, Korea
1998 Bachelor of Fine Arts, Department of Metalwork
 and Jewelry, Kookmin University, Seoul, Korea

Solo Exhibitions

2015 *Archisculpture*, ILWOO Space, Seoul, Korea
2014 *Wonbeomsik Art Exhibition*, Cheongju Art Studio
 Gallery, Cheongju, Korea
2014 *Archisculpture Collage*, Soohoh Gallery, Bundang, Korea
2014 *Archisculpture Antigravity*, Gallery NUDA, Daejeon, Korea
2013 *Archisculpture*, Toyota Photo Space, Busan, Korea
2013 *Archisculpture*, Gallery Lux, Seoul, Korea
2008 *Dimension Finder*, Gallery Lux, Seoul, Korea
2006 *On a Journey*, Gallery Gainro, Seoul, Korea

Group Exhibitions

2015 *Art Exhibition for Children*, Jeonbuk Museum of Art, Wanju, Korea
2015 *Art Space J Show*, Art Space J, Bundang, Korea
2015 *Open Studio Group Show*, Cheongju Art Studio, Cheongju, Korea
2015 *Out There*, Miboo Art Center, Busan, Korea
2014 The 8th Sharing Love Exhibition by Soohoh Gallery,
 Sungnam Art Centre, Sungnam, Korea
2014 *Post-Photo*, HoMA, Hongik University, Seoul, Korea
2014 *Lead_At This Moment*, Grimson Gallery, Seoul, Korea
2014 *Ghost Memories Exhibition*, Cheongju Art Studio, Cheongju, Korea
2014 *J Collections*, Art Space J, Bundang, Korea
2014 Cheongju Art Studio 8th New Artist Exhibition,
 Cheongju Art Studio, Cheongju, Korea
2014 American Aperture Awards, *AX3*,
 Photo Independent, Los Angeles, CA, USA

2014	The 5th New Artists Exhibition,
	Soohoh Gallery, Bundang, Korea
2013	*Desires*, Art Space J, Bundang, Korea
2013	*Dark to Light*, H.M. Tower of London, London, UK
2013	*The Secret Garden: CHOI&LAGER Project*,
	LE FUR CHOI, Paris, France
2013	*Other Spaces: Re-imagining Architecture*,
	Bosse & Baum Art, London, UK
2013	*Candid Arts Exhibition*, Candid Arts Trust, London, UK
2012	The 5th UK Korean Artists Exhibition, *Now X Here*,
	Korean Cultural Centre, London, UK
2012	*The Salon Art Prize 2012*, The Griffin Gallery, London, UK
2012	*Brush*, The Greenwold Art Company,
	Concrete in Shoreditch, London, UK
2012	*The Recent Graduates' Exhibition*,
	Battersea Evolution, London, UK
2012	*The Salon Art Prize 2012*,
	Matt Roberts Arts Gallery, London, UK
2012	*53 Degrees North Exhibition*,
	The New School House Gallery, York, UK
2012	*MFA Fine Art Degree Show 2012*,
	Slade School of Fine Art, UCL, London, UK
2012	*The AOP Students Awards 2012 Exhibition*,
	Hoxton Gallery, London, UK
2012	*Place Not Found*, Forman's Smokehouse Gallery, London, UK
2012	*Map the Korea: 4482*, Bargehouse Gallery, London, UK
2011	*Slade Interim Show*, Woburn Square, UCL, London, UK
2008	*Post-Photo*, Hongik University and
	Topohaus Gallery, Seoul, Korea
2007	*Post-Photo*, Hongik University and
	Kwanhoon Gallery, Seoul, Korea
2005	The 40th Donga Newspaper International Photography
	Exhibition, Ilmin Museum, Seoul, Korea
1997	*Kookmin University Chohyung Exhibition*,
	Kookmin University, Seoul, Korea
1992	*Wonju Artists in Seoul Exhibition*,
	Wonju Cultural Centre, Wonju, Korea
1991	*Wonju Artists in Seoul Exhibition*, Catholic Centre, Wonju, Korea

Awards

2013	Winner, 2013 ILWOO Photography Prize,
	ILWOO Foundation and Hatje Cantz, Korea and Germany
2013	Selected, The 5th Soohoh Gallery New Artists Awards,
	Soohoh Gallery, Korea
2013	The Top 100 Finalists, Art Takes Paris, Paris, France
2013	First Prize (Professional Collage Category),
	American Aperture Awards, *AX3*, Los Angeles, CA, USA
2013	First Prize, Gallery Lux Emerging Artists Awards,
	Gallery Lux, Korea
2013	Selected, Candid Arts Exhibition, Candid Arts Trust, UK
2012	Selected, The 5th UK Korean Artists Exhibition, *Now X Here*,
	The Korean Cultural Centre, UK
2012	Selected, The Salon Art Prize, Matt Roberts Arts Gallery, UK
2012	Selected, 53 Degrees North Exhibition Award,
	The New School House Gallery, UK
2012	The Merit Prize (first), The AOP Students Awards, UK
2005	The Silver Prize (second), The 40th Dong-A Newspaper
	International Photography Competition, Seoul, Korea
1996–97	Winner, The 1st & 2nd Yoon Design Font Development Contest,
	Korea

Collections

Daelim Museum, Korea
Cheongju City Hall, Korea
National Museum of Modern and Contemporary
Art Bank, Korea
Gallery [Soohoh], Korea
Gallery [Union], UK
Gallery [Art Space J], Korea
Law Firm [South Square], UK
Numerous Private Collections

BEOMSIK WON
Archisculpture

is published in conjunction with the 2013 ILWOO Photography Prize.

**ilwoo
foundation**

The ILWOO Foundation encourages talented artists and supports
various art and cultural events.

Korean Air Building
Seosomun-dong, Jung-gu
Seoul, Korea
Tel. +82 2 753 6505

Creative director: Suejin Shin
Copyediting: Leina González
Graphic design: Andreas Platzgummer, Hatje Cantz
Typeface: Gravur Condensed, Fedra Sans
Paper: LuxoArt Samt, 150g/m²
Production: Heidrun Zimmermann, Hatje Cantz
Reproductions: Jan Scheffler, prints professional
Printing: Offsetdruckerei Karl Grammlich, Pliezhausen
Binding: Lachenmaier GmbH, Reutlingen

Published by
Hatje Cantz Verlag
Zeppelinstrasse 32
73760 Ostfildern
Germany
Tel. +49 711 4405-200
Fax +49 711 4405-220
www.hatjecantz.com
A Ganske Publishing Group company

Hatje Cantz books are available internationally at selected bookstores.
For more information about our distribution partners please visit our
website at www.hatjecantz.com

ISBN 978-3-7757-4030-2

Printed in Germany

Cover illustration: *Archisculpture 038*, 2014
Back cover illustration: *Archisculpture 040*, 2014

© 2015 Hatje Cantz Verlag, Ostfildern; and authors
© 2015 for the reproduced works by Beomsik WON: the artist

9. 10.15

Leeds College of Art
Library
779 WON
R94154k

LEEDS COLLEGE OF ART

R94154K0084